To Patricia

From Anna

Christmas 1981

SPANISH DRAWINGS

DRAWINGS OF THE MASTERS

SPANISH DRAWINGS

From the 10th to the 19th Century

Text by F. J. Sánchez Cantón

LITTLE, BROWN AND COMPANY [LB] BOSTON · TORONTO

A

LIBRARY OF CONGRESS CATALOGING IN PUBLICATION DATA

Sánchez Cantón, Francisco Javier, 1891–1971.
 Spanish drawings from the 10th to the 19th century.

 Reprint of the ed. published by Shorewood Publishers, New York,
issued in series: Drawings of the masters.
 Bibliography: p.
 1. Drawings, Spanish. I. Title. II. Series:
Drawings of the masters.
NC285.S28 1976 741.9'46 76–1887
ISBN 0–316–12786–8

Published simultaneously in Canada
by Little, Brown & Company (Canada) Limited

PRINTED IN THE UNITED STATES OF AMERICA

Contents

SPANISH DRAWINGS

It has been the practice of those of us who have concerned ourselves with Spanish drawings to complain about their scarcity with gross exaggeration. We should have complained rather about the small amount of research and investigation of the subject. The 6,923 drawings catalogued by A. M. de Barcia at the Biblioteca Nacional of Madrid in 1906, a number that has since grown, the drawings of the Prado Museum, which exceed 2,000, those of the Biblioteca del Palacio Real and of the Real Academia de Bellas Artes de San Fernando, also numerous, and the collection of the Museo Lázaro Galdiano, without counting the other smaller but valuable collections, like that of the Instituto de Valencia de Don Juan, demonstrate that without leaving the Spanish nation's capital, the complaint of scarcity can be dismissed. Add the extensive collections in Barcelona, Valencia and Saragossa—although the very select and abundant collection of the Instituto Jovellanos of Gijón was lost in 1936—and one can surmise how promising is the task that awaits scholars in this hitherto little cultivated field. Outside of Spain substantial collections have been preserved by The Hispanic Society of America in New York, the Louvre, The British Museum, and the Uffizi Gallery. Of the half-dozen great artists of Spain, only one—Goya—left hundreds of known drawings; those definitely attributable to Diego Velázquez can scarcely be counted on the fingers of one hand; Francisco de Zurbarán, not even that; and of Jusepe de Ribera and Bartolomé Murillo, very few. In the golden century of Spanish painting only Francisco Pacheco, Alonso Cano and Antonio del Castillo were fond of drawing, judging from their known samples; and there is no lack of drawings by painters of the Madrid School, Juan Carreño and Claudio Coello.

The Spanish artistic temperament was and is undoubtedly given more to the magic of color than to the discipline of drawing, so that artists frequently drew on canvas with brush and paint without previous attempts on paper or, when they did render drawings, discarded them after use. There is documentary evidence that Velázquez worked on occasion without preparatory drawings on paper.

Although for various reasons the series of great Spanish draughtsmen has to be presented with historical gaps, it does, on the other hand, date back to medieval times.

Spain having been the land where the three vital currents of medieval culture, namely, Italian, Northern and Moslem, met and crossed, the arts were enriched with highly diverse elements which, working on a classical tradition, gave rise to a splendid florescence. The variety of architectural styles and profusion of ornamented manuscripts, at least since the ninth century, give proof of an admirable development of drawing.

Although the celebrated *Ashburnham Pentateuch* of the Bibliothèque Nationale of Paris is indubitably not Spanish, it is certainly akin to Visigothic illustrated codices in scenes full of vitality and with figures observed from life. There are abundant references to manuscripts in libraries of Spanish cathedrals and monasteries from the middle of the eighth century.

Some one hundred years later in the *Biblia,* beautifully calligraphed, and now preserved at the Benedictine monastery of Trinidad, near Salerno, Danila, with a skillful and steady pen, adorned the capital letters with stylized birds and fishes. The same theme is found, treated with sated emotion, in the manuscript, *Biblia Hispalense,* which, traced to Seville in 988, is now at the Biblioteca Nacional of Madrid after having spent centuries at the Cathedral of Toledo. The vibrant emotion of the artist, which one might call impassioned, is expressed most forcefully in the figures of prophets, like *Naum* and *Zachariah,* in which the characteristic attraction of the observer exerted by Spanish painting is already evident. This is an art to which no one can remain indifferent; it is the art that, after a thousand years, produced a Picasso.

Another lasting characteristic of Spanish drawing may be seen by observing, in this book, the skillful silhouettes of some drinkers on the margins of the *Libellus Scintillae Scripturarum* of Alvaro de Córdoba, from the tenth century, in the Real Academia de la Historia. The swift, barely-marked strokes reveal an acute power of observation. In the monastic scriptorium the copyist, resting from his toil, would observe the servants of the monastery and sometimes record their attitudes. There was an incipient taste for the profane life later manifest in the painting of the 1600's.

If, besides these whimsical and spontaneous flights of the artist illustrating manuscripts, one places the adornment of a page that reveals the hieratic aspect of his labor, one can realize how, amidst constructive pomp and circumstances the temperament of the draughtsman praised freedom. An example is the handsome page from the *Explanatio in Apocalypsis S. Johannis,* written by San Beato de Liévana and which Monius and Emeterius Presbyterus, disciples of Magius, finished illustrating at the monastery of Tábara on July 28, 970. It was a great artist who handled the space marked by the Mozarabic arch and represented *Belshazzar's Feast*. (Archivo Histórico Nacional, Madrid), reproduced here, with expressive vigor at the bottom of the page.

Even more magnificent is the decoration by Facundus of the text in the manuscript *Commentary on the Apocalypse* (1047), made for King Ferdinand I, which is kept at the Biblioteca Nacional of Madrid in a remarkably good state of preservation. Admire the *Initial A,* reproduced here, in which the profuse detail of the interlaces does not impair the monumental nature of the figures.

The fully constituted Romanesque style showing examples of lively creations, along the same lines as those of two centuries earlier, can be seen in the illustration reproduced here from a *Choir Missal*. (Real Academia de la Historia), that was done at the end of the twelfth or the beginning of the thirteenth century. The illustration, on the side of which are musical notes, shows a dramatic scene of a demon biting a sinner. The entire page creates a moving effect. In the *Vitae Patrum Orientalium,* (Real Academia de la Historia), one

finds drawings, unexcelled in the twelfth century, in which it seems that the artist seeks to reproduce real statues.

Because of the rarity of drawings with artistic quality in the tenth to twelfth centuries, it is not necessary to treat that period in this commentary, but to pass on to the consideration of the thirteenth and fourteenth centuries, during which period Spain was an important province of Gothic Art.

The eagerness to draw from life gave rise to lifelike sketches, using in some cases blank spaces in previous manuscripts. In a Mozarabic Homily from the Real Academia de la Historia, an armed horseman fighting a monster—*St. George and the Dragon,* undoubtedly—dating from the thirteenth century, resembles in spirit and technique the previous drawings. The same style is found in scenes illustrating, also in outline, the poem *Libre de Alexandre,* (Biblioteca Nacional), a thirteenth century manuscript. By the twelfth century the illustration of manuscripts, while fundamentally drawings, becomes more specifically illuminated painting with generalized use of paints and gilt. Exceptions, however, are not uncommon. The *King of Aragón with Jester and Monkey* is a court scene of surprising naturalism from a miscellaneous codex in El Escorial; the five lively figures of dogs from the *Chronicle of Alfonso XI* at the Library of El Escorial is a manuscript made for Henry I.

The Spanish character in the tenth to twelfth centuries and maintained in the following two, diminished considerably in the field of drawing in the fifteenth century. There is no comparison of Spanish drawings with those of Italy, Flanders or Germany. Furthermore, since the few published examples are not from Spanish hands, though of Spanish style, one cannot be sure about others.

The illustrations in the manuscript of the *Book of Calila and Dinna,* a fable of oriental origin, executed with narrative mastery, are delightful. The manuscript belongs to the Library of El Escorial and was the property of Isabella the Catholic.

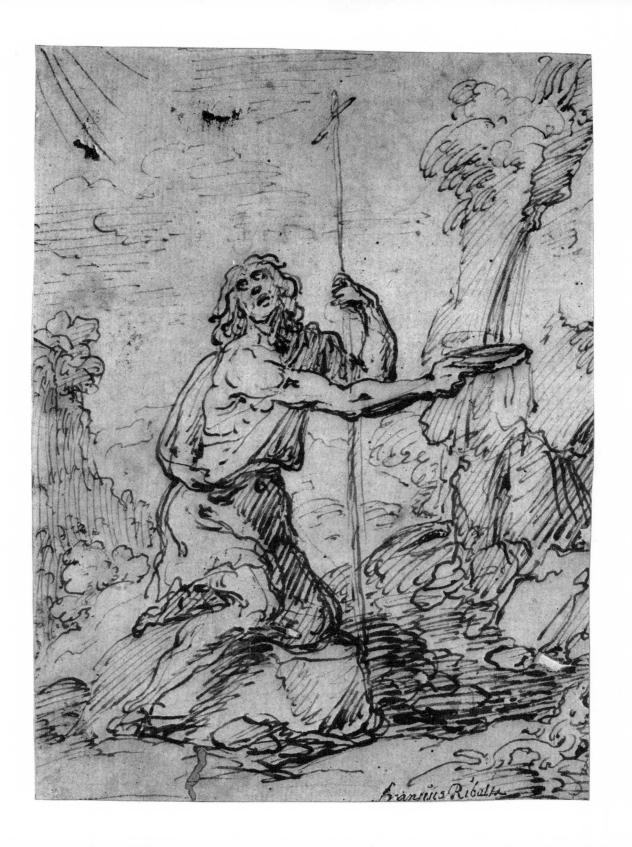

Franciscus Ribalta

15

With facile and thoughtful pen an artist named Resuallo copied and, it is to be believed, ornamented for Don Diego de Anaya, Archbishop of Seville (d. 1437) the strange book, *Universal State*, (Biblioteca del Palacio Real), ascribed to one Friar Theolophorus. It is a treatise on prophecies, and the pen drawings show a firm stroke and satirical sense.

Another manuscript, *Genealogia de los Reyes*, (Biblioteca del Palacio Real), by Don Alonso de Cartagena, Bishop of Burgos, is profusely ornamented revealing rich imagination, particularly with coiffures and costumes. The artist, perhaps not Spanish, is unknown.

Nor was Juan Guas Spanish, but rather a Frenchman who must have come as a youth to Spain. Trained as an artist in Toledo, he adopted a national style as demontrated by the architecture of his main work, the Church of San Juan de los Reyes in that city. For this church he drafted on parchment the main chapel with its retable. This is one of the major drawings preserved at the Prado.

Also exceptional is the large drawing representing *The Annunciation* on the outside of a triptych of the Museo Lázaro Galdiano of Madrid. Outlined on panel, it is not known whether it was made to be finished with brush and paint or whether it was an interpretation *sui generis* of the known practice of painting in "grisaille" (greenish-gray paint) the backs of "volets" (wings of altarpieces). In any event, the work merits study. The triptych was classified as "attributed to García del Barco," a painter who worked in Avila where the painting originated. In the open triptych *The Nativity* appears between the *Annunciation to the Shepherds* and the *Journey of the Magi*. The American Hispanist, Charles R. Post, who classified the painting as the work of the "Master of Avila," without naming him, believes it dates back to 1470-75 and compares it with the *Bladelin Triptych* by Roger van der Weyden at the Berlin Museum, although he points out the evident Spanish features.

From the examples cited it is understandable that technical perfection is

not to be sought in medieval Spanish drawings, even in those belonging to the fifteenth century, nor is the taste for analyzing form to be found, let alone studies of garments or close likenesses of faces or analysis of plants or flowers. But, in compensation, one will often find natural impression, expressive power, immeasurable intensity and the ability to handle, not light—for that centuries would have to elapse—but rather contrasts. It might be said that if Italian drawing foretold Leonardo and Raphael and that of the artists of the North pointed to Dürer, Holbein, Bruegel and van Dyck, the drawing of the Spaniards led to El Greco, Velázquez and Goya.

Spanish drawing in the sixteenth century does not clearly exhibit national qualities. The Italianizing trend dominated our art, and we lack drawings of the first Renaissance influences which would be most meaningful. It was logical for artists who were in Italy, like Alonso Berruguete, Gaspar Becerra, Juan Fernández de Navarrete "El Mudo," Pablo de Céspedes and Luis de Vargas, or who, without having been there, took very direct inspiration, like Juan de Juanes, to have their own personalities subjected to the overwhelming influence, particularly when Mannerism was established everywhere.

A painter who was above all a sculptor was the Castillian, Alonso Berruguete whose existing drawings are few. In fact, only three are definite: the beautiful *Christ in Transfiguration,* (Uffizi Gallery), for the group of carvings he executed at the Church of Salvador de Ubeda, and the vibrant drawing, *Studies for a Crucifixion,* (Real Academia de Bellas Artes de San Fernando), which reveals the Italian sojourn in the influence of Michelangelo. With its aura of magnificence, *An Apostle,* from the same Academy, drawn with impressive decisiveness, can be ascribed to him.

Another artist who was a painter and sculptor like Berruguete and trained in Italy, Gaspar Becerra who, according to old records, drew the anatomical plates for *History of the Composition of the Human Body* (1556), by Juan Valverde de Amusco, was the designer of great retables, including that of the

Cathedral of Astorga. There are drawings of two other retables at the Biblioteca Nacional of Madrid, which show the mastery of the artist over this peculiar form of Spanish art. The second one dates back to 1563 and was burned in 1862.

Samples for two other painters, Juan Fernández de Navarrete "El Mudo" and Pablo de Céspedes, who also worked in Italy, can be provided to show their acceptance of the formulas of the late Renaissance. The former was at Titian's studio, and Philip II employed him as his favorite artist at El Escorial. He probably drew *The Flagellation*, (Biblioteca Nacional), for the great monastery, although it differs considerably from the painting that is in the high cloister. Surprising is the corporeal quality achieved with extreme frugality of means. A different and more painstaking procedure was followed by the erudite artist Céspedes, in the very finished study which he signed with his intials and which, after having belonged to Ceán Bermúdez in the eighteenth century and to Lefort and Fernández-Duran in the nineteenth, is today at the Prado. It is a definitive piece of Italianism achieved by Spanish drawing. So are the drawings of Juan de Juanes for the *St. Stephen Series,* two of which are at the National Museum of Stockholm. The dissemination of taste and technique was such that little-known artists drew with mastery; for example, an Aragonese named Teodosio Mingot is author of an excellent study for a *Descent from the Cross,* (Biblioteca del Palacio Real), which few would consider Spanish. Such a drawing illustrates the universality of art in that epoch.

In the last quarter of the sixteenth century, Spanish art reached the threshold of its glory. Besides the center at El Escorial that was Mannerist—because of the artists who worked there and the acquisition of Venetian paintings by Philip II which revitalized the surroundings—three other centers were formed: Toledo, Seville and Valencia.

The first was dominated by El Greco. His known drawings which are scarce, have magnificent forms handled in the Venetian manner, stylistically

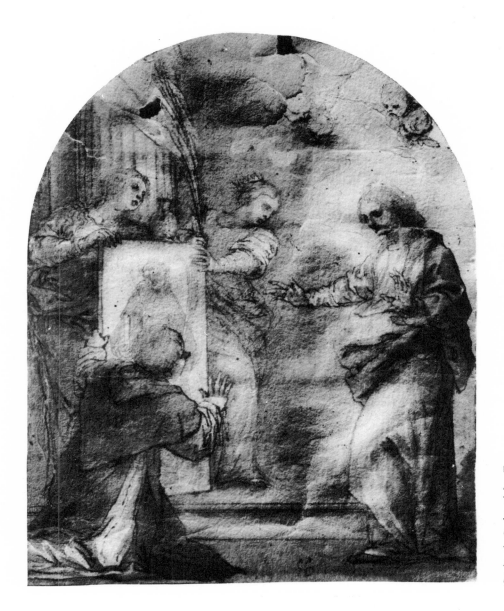

Figure 2
Alonso CANO
The Apparition of
St. Dominic in Soriano
quill pen strengthened
with sepia
5⅜ x 4⁷⁄₁₆ inches
Madrid, Prado

close to Tintoretto. Possibly the earliest is in the Munich, Staatliche Graphische Sammlung, a sketch of Michelangelo's *Day* on which there is inscribed in capital letters, DOMINICO GRECO.

The imposing figure of *St. John the Evangelist* with the eagle, (Biblioteca Nacional), a study for the retable of Santo Domingo el Antigua of Toledo in 1577, is assigned to El Greco with complete certainty. Another certain work is *St. Matthew with the Angel* which has actually been identified as a St. John. As St. Matthew, it does not correspond to any known painting on that theme. If it were a study for a *Crucifixion,* to which it presents undeniable similarities, it is surprising that the Apostle-Evangelist was not shown beardless, as was customary. The doubts brought up with respect to this drawing do not seem well-founded. The proceedings of the sale of the painter Mariano Fortuny's collection, held when the fame of El Greco was very limited, favored the authenticity of this drawing, which was later affirmed by A. M. Hind, T. Borenius and A. L. Mayer.

Two facts must be remembered about the drawings of the Cretan painter: the answer he gave the Seville painter and writer, Francisco Pacheco, when asked, in 1611, whether drawing or coloring was more difficult—he responded with "color"; and the fact, that in spite of the small number of his surviving drawings, the inventory of his studio registers 150. The meager sampling of drawings by El Greco which have been preserved can be explained only by great losses. Those published here reveal more than eagerness to study details, which do not stop at faces and hands, so expressive in this artist, but which extend to the study of rendering volumes of the figures and of their ample draperies. Moreover, our influences depend only on those examples that can conservatively fit into the discussion of El Greco's drawings.

Working in the Seville center after 1593 was Francisco Pacheco, an extraordinary draughtsman, who was to be teacher and father-in-law of Velázquez. He frequently dated many of his drawings, declaring in 1638 that he had done as many as 170. These works reveal a cultivation for the most varied genres

and a predilection for the color-pencil portrait. Still preserved are those constituting the remarkable volume, dated 1599, at the Museo Lázaro Galdiano and a few separate portraits like *Portrait of The Doctor Bartolomé Hidalgo,* (Real Academia de Bellas Artes de San Fernando), reproduced here. Aside from portraits executed with dexterity, Pacheco did mostly pen sketches and water colors of saints or religious compositions, although he also painted several ceilings with mythological themes.

Around the same period in Valencia, Francisco Ribalta, with a more modern spirit, coinciding with that of Caravaggio, established bases for the realism later so prevalent in Spain.

The influence exerted by Ribalta on the art of Jusepe de Ribera, called "Lo Spagnoletto," though not easy to document, cannot be denied. Residing almost his entire life in Italy, specifically in Naples, Ribera boasted, on signing many of his paintings, of being a Spaniard and native of Valencia. Not only does his painting reveal mastery and dedication in the field of drawing, but, surely because he resided outside the country, in Naples, a viceroyalty of Spain, he was fond of engraving, an art which few Spanish painters practiced. He designed the prints engraved by Francisco Fernández for *Livre de Portraiture.* There should be an abundance of drawings of "Lo Spagnoletto"; however, that is not the case. The majority of drawings that appear to be Ribera's are by disciples and Neapolitan imitators, principally Luca Giordano. The few assured drawings of Ribera give an idea of the expressive vigor of his stroke and of the sobriety of his modeling. He repeated the theme of the hanged or crucified martyr, almost always with the head down. Other drawings of his were swift notations from life, which might be called fleeting. An exception is the beautiful portrait of his daughter at the Filangieri Museum in Naples, one of the most perfect Spanish drawings, masterly in its minute precise handling and impregnated with emotion.

Ribera's contemporary, Velázquez, marks the peak of Spanish painting. But drawings by this unmatched painter are also surprisingly scarce, especially

since, his teacher, Pacheco, mentions those he executed from adolescence on blue paper with charcoal and touches of white. The way Pacheco speaks of Velázquez' drawings surely indicates an intense study of this technique, of which no samples remain. So rare are the drawings of Velázquez that the modern collector can barely satisfy his eagerness to attribute drawings to him. And it is to be added that several of those ascribed to him are surely remote from his work; I must point out that of those reproduced here, I have great doubts as to *A Dog*, (Biblioteca Nacional), and *Portrait of a Girl*. The latter one, from The British Museum, has been ascribed to him because the paper and medium used are those indicated by Pacheco. He was not the only one, however, to use them. On the other hand, I am becoming more and more certain that the *View of the Cathedral of Granada*, (Biblioteca Nacional, Madrid), is the master's work. He must have drawn it in 1629 when, on his way to Málaga, from whence he would sail for Italy, he stopped in Granada at the residence of Alonso Cano. The mastery over the division of light and shadow reveals a great painter. It is inconceivable how a man of calm reflective disposition like Velázquez, who studied precedents for his compositions, has not left numerous drawings, but only brief sketches for great paintings like *The Surrender at Breda*. The theory that they have been lost seems hardly satisfactory, since the fame of the great artist has never been eclipsed.

Professor Camón believes that the drawing on blue paper with pen and water color, representing *The Embarkation of a Multitude*, acquired in London by the Prado, is the work of Velázquez. He relates it logically to the contest held among the painters Velázquez, Nardi and Vicente Carducho in 1627 on the theme of the Expulsion of the Moors. Velázquez won the prize and his painting was lost in the fire at the Alcazar of Madrid in 1734. But it is to be noted that, according to the description, in the center was King Philip III and, on his right, Spain, in the figure of an enthroned majestic matron. That the drawing is for one of the three paintings seems evident to me from

its characteristics and I believe it must be considered the work of Vicente Carducho. Born in Florence, Carducho came to Spain with his brother, while a child. He was a prolific painter and a good draughtsman, in addition to the writer of *Dialogues on Painting*, published in 1633, where, in several passages, he alludes disdainfully to Velázquez. However, both Carducho and Velázquez were painters for Philip IV, collaborating in series like *The Youthful Victories* of this King in great canvases painted for El Buen Retiro.

Among others participating in the same series of paintings was Jusepe Leonardo, a native of Aragon, who failed when presented as the only one who in any way came close to Velázquez. A clear idea of his talents is provided by the drawing for his *The Surrender of Juliers to the Marquis of Spinola*—drawing and canvas at the Prado—which reveals his abilities as a portraitist, colorist and painter capable of giving the feeling of the surroundings.

Francisco de Zurbarán and Antonio de Pereda also painted canvases for the same place. The former is one of the greatest Spanish artists, but there is a total absence of drawings that can be definitely ascribed to him. A few of Pereda's have been preserved. *St. Jerome Writing,* (The British Museum), sturdy in modeling and vigorous in coloring, is typical.

The drawings of no other Spanish artist of the seventeenth century can be compared in number, quality or variety with the drawings of a native of Granada, Alonso Cano, a Renaissance spirit misplaced in the Baroque period. He retained the curiosity, multiplicity of talents—architect, sculptor and painter —and strived for a perfection that characterized the great figures of the previous century. His restlessness drove him on to continuous study and experimentation, handling Italian and Flemish engravings, but not imitating them. As a superior artist, both an inventor and draughtsman, Cano was much imitated and copied in his own time, testifying to the recognition of his importance by his contemporaries. Although he preferred religious themes—like all of the Spaniards of that time—there is no lack of architectural studies, particu-

larly retables and fountains, and allegories for book covers, including nudes, so uncommon in seventeenth century Spain. The drawings reproduced in this book require no further explanation to understand readily their qualities.

The fact that he practiced three arts resulted in a considerable number of drawings. Their variety and perfection have long been recognized, interesting collectors and resulting in large collections of his work. The *Catalog* of the Biblioteca Nacional enumerates 37, 25 were lost in the fire at the Jovellanos collection of Gijón, 50 are in the Prado. Others exist in the Academia de Bellas Artes de San Fernando, the Biblioteca del Palacio Real and the dissolved collections of Boix and Beruete. It might have been possible in 1936, perhaps without leaving Spain, to arrive at a number around 150, some copies and other problematic in their attribution.

Following closely behind Alonso Cano, because of the quantity of his work as a draughtsman, is the native of Cordova, Antonio del Castillo. He distinguished himself as a draughtsman specializing in pastoral genre scenes, indicating perhaps that he was planning series of prints, although, like Cano, it is not known whether he was an engraver. Nor is it known whether he painted portraits, although we have evidence of his faculties for this genre from the drawing reproduced in this book. Castillo is an artist hitherto little studied, but one who well deserves to be.

The *Catalog* of the Biblioteca Nacional includes 29 drawings of the painter, in general, correct in their attribution, since A. M. Barcia was a connoisseur of Castillo, being his fellow-townsman. On the other hand, in Gijón there were 43—more than one signed by Castillo among the drawings of Cano —some of which were uncertain in attribution. Both the Prado and the Real Academia de Bellas Artes de San Fernando own notable examples by Castillo.

In Volume iii of my catalogue, (1930, Madrid) *Dibujos Espanoles,* 34 Castillo drawings are reproduced, most of them signed with a monogram and in one exception with his whole name. Thus it can be said that Castillo alone

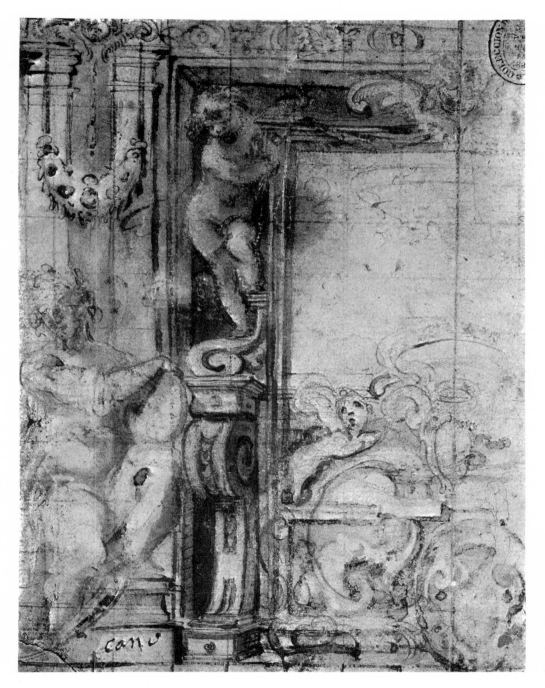

Figure 3
Alonso CANO
Decorative Fragment
(sketch for ornament in one of
his architectural projects)
black and red stone with
India ink and touches of white
7$\frac{1}{16}$ x 1$\frac{1}{2}$ inches
Madrid, Biblioteca Nacional

can be compared with Cano, as a practitioner of drawings among the Spaniards of that time.

Ceán Bermúdez wrote in his *Diccionario* (1800): "As he has drawn a great deal, there remain many designs by his hand owned by professors and artists, and I myself have a good many of them. He made them with a very fine quill pen and other items with reed pens; some freely and masterfully executed in India ink."

If we return to Madrid, we shall find among the painters who were living at the time of Velázquez' death two very important representatives of the Baroque style: Juan Carreño and Claudio Coello. The former was a great portraitist with the very Spanish trait of proving himself independent in his works from the immediate heritage of Velázquez, for he preferred to study van Dyck and Rubens, just as his knowledge of the Venetians is evident in his religious painting. He was an admirable draughtsman of innumerable resources, achieving beautiful color effects, seen in his drawing, *Two Apostles*, (Biblioteca Nacional). This was probably for a fresco painting, a technique he also cultivated. As for portraits, the Prado preserves a male study, and a beautiful head of a woman executed with smoothness and mastery. An example of his religious painting, *St. Isidor the Tiller*, (Real Academia de Bellas Artes de San Fernando), reproduced here, is a drawing intended for the great canvas painted for the Madrid chapel of his appellation, destroyed in 1931.

The drawings of Carreño always reveal the painter: wash and color produce the effect of elegance that marks his paintings, already discernible in his drawings. It should be remarked that nearly all the drawings are of agile figures, not of completed compositions, as is also the case of Velázquez and most Spanish artists, including Goya, as we shall see. It is worth emphasizing that although Carreño was a great portrait painter, only two of his studies for portraits are known, whereas we have various portrait studies by Coello, of per-

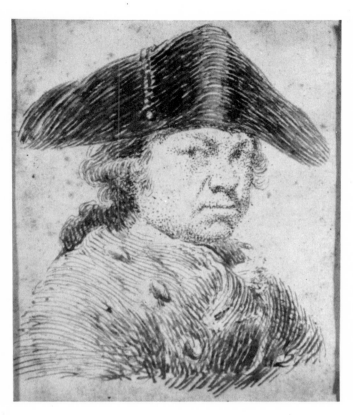

Figure 4
Francisco GOYA • *Self-Portrait*, 1790-92 • pen and ink
4⅛ x 3⅞ inches • New York, The Lehman Collection

Figure 5
Francisco GOYA
Portrait of the Artist's Son, 1824
black chalk
oval (3⅝ x 3¾ inches)
New York, The Lehman Collection

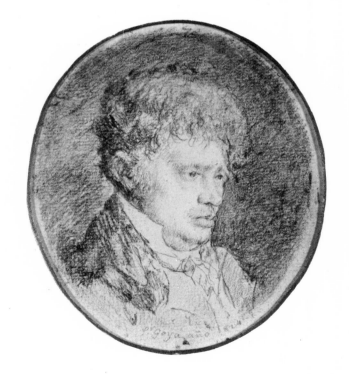

sonages he painted in the great canvas, *The Transfer of the Holy Eucharist,* done for the sacristy of El Escorial.

Claudio Coello, younger than Carreño, was the other great Baroque artist of the Madrid School. In 1684 he was named Painter to the King and, in 1686, he became Court painter. His works resemble Carreño's, but are not to be confused. *The Martyrdom of St. John the Evangelist,* on the altar of the parish church of Torrejón de Ardoz (Madrid), is undoubtedly the most beautiful religious composition of the School, and his drawing, reproduced here, eloquently expresses it. As it might be inferred from his dates, Coello's drawings present Baroque characteristics, especially since he was, in addition to being a painter, a decorator, devising whole schemes or ambiences of flying angels and figures in ecstasy and mythological representations. A sample of a genre, scarce in Spain, is the plan for a ceiling which Coello executed with facile pen and precise stroke. The eminently pictorial technique—therefore, characteristic Spanish drawing—employed for the painting at the Prado, dated 1669, when the artist was 27, proves once again that the Madrid painters turned to Venetian and Flemish sources, ignoring their immediate national heritage.

Far from the Court, the group of Seville artists, in the second half of the seventeenth century, included artists like Murillo and Valdés Leal, who were as averse to drawing or to preserving their drawings as almost every other artist in Spain. Murillo employed different techniques; the pencil with mastery in *The Child St. John the Baptist with Lamb,* (Prado), the drawing of fascinating simplicity and smoothness; black charcoal with white touches used in *Study for a St. Francis of Assisi,* (Biblioteca Nacional), or the more complicated technique of *An Apparition of the Virgin and Child to a Monk in Ecstasy,* (Musée Condé, Chantilly). It is to be assumed that the *Rider and Galloping Horse,* (Biblioteca Nacional), executed in pencil with great fluidity, comes from the last period of the great painter. Some doubt arises to the attribution, appearing in old characters on the lower lefthand corner. However, there can be no doubts about the *St. Felix of Cantalice Holding the Christ*

Child, (Pierpont Morgan Library, New York). The painter's production of drawings was limited almost exclusively to the religious genre; there are no known drawings of his few portraits and landscapes.

Murillo's style as a draughtsman is characterized by a rare gentleness, which agrees with his temperament. In the subsequent revision of Murillo's reputation, declining in recent years, his fine and careful drawings must also be considered.

Valdés Leal liked to draw his compositions in minute detail, as shown by the two reproduced in this book.

A brief glance at a genre, highly developed at the end of the century, completes the panorama of the development of sixteenth century Spanish drawing: plans of ephemeral structures for fiestas or for commemorations—arches, catafalques, processional floats—with allegories predominating. A typical example is the drawing of Francisco de Herrera "El Mozo," a Sevillan, who with agility and imagination drew a processional float, *The Vision of St. John on Patmos,* (Pierpont Morgan Library, New York).

In contrast, a trend to restrict the exaggerated Baroque style appears, personified by a modest painter but excellent draughtsman, and author of numerous "Academies," Juan Conchillos. Conchillos, a Valencian, liked to sign with the date and sometimes indicated the very hour. He died in 1711.

That the turn of century did not involve a break with the dominant style can be seen in the work of José Churriguera. Churriguera was a prolific designer of retables of highly intricate lines and adornments. His drawing was wonderfully swift, just the opposite of that usually encountered with the slow reflective analysis of forms. As an example of the anticlassical predilections of Spanish art, none more representative will be found.

As is known, the eighteenth century developed academic neoclassicism. When Anton Raphael Mengs came to Madrid in 1761, the groundwork was already laid at the Spanish Court, because the Real Academia de Bellas Artes de San Fernando had been founded nine years earlier. It would be irrelevant

to describe the changes in subjects and techniques brought on by such innovations; it will suffice to show examples proving the point, indicating the influence exerted on the development and esteem attained by drawings. The previous scarcity was more than offset, but the progress of time does not alone account for this; hundreds of drawings of Francisco Bayeu, Luis Paret, Manuel Salvador Carmona and Goya have been left to us, displaying a variety of processes and subjects previously uncommon in Spain.

Francisco Bayeu, brother-in-law of Goya, was a tireless draughtsman, handling the pencil with particular adroitness and frequently using touches of white on blue paper. For his frescoes in the cloister of the Toledo Cathedral, he carefully studied details of garments and weapons.

A sensitive and graceful artist moved by French influences was Luis Paret. He was accomplished in book illustrations and in fête-galante scenes. In the same genre, though less artistically, José Camarón also distinguished himself.

An expert draughtsman and also an engraver, Manuel Salvador Carmona has left admirable portrait and ornamental studies.

In Goya we come to the foremost art draughtsman among the Spaniards. It is to be observed, however, that like the other Spaniards, he almost never made preliminary studies and drawings for his pictorial compositions or figures, let alone details; ideas and sketches for composing his paintings are extremely rare. For Goya, drawings were complete works to be engraved or to stand alone without being transferred to the copper plate or lithographic stone—when that process was invented. Note that this sense of considering his drawings as creations, not auxiliary studies but definitive works, prompted him to repeat them in many instances, modifying lines and varying techniques. This sort of practice would be regarded as unlikely in a man who rendered paintings in every genre apparently without prior studies, except in the case of religious subjects, for which he usually sought precedents and did make drawings and sketches, trusting little to his characteristic ingenious improvisation. Limited to the few examples represented here, the innumerable

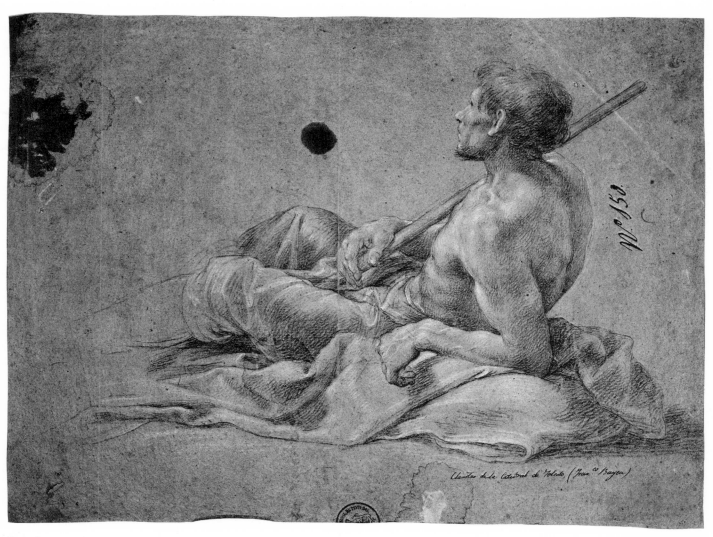

Figure 6

Francisco BAYEU • *Figure Study for the Cloister of the Cathedral of Toledo, 1787* • pencil with touches of white on blue paper
14⅝₁₆ x 19⅛₁₆ inches • Madrid, Prado

aspects of "Goya the draughtsman" are to be considered the very minimum, but bear in mind the wealth of published material on this facet of his creative genius.

An effort has been made to compile drawings that will elucidate the variety of processes, inspirations and tasks he set for himself in his engravings, paintings and expressions of his sometimes bold ideas and feelings. B. Gallardo, a literary figure who was a contemporary of Goya, characterized the great artist as the "painter philosopher." Today we would not describe him thusly. Goya's profundity, more of feeling than of thought, causes us to find ourselves closer to him and to understand him better than did the philosophers of his time.

Academic discipline maintained the perfection of drawing in the first half of the nineteenth century and, far removed from the Goya-like temperament, several painters deserve mention, so that their heretofore limited fame may be spread.

Two of them, born in the eighteenth century, were contemporaries of Goya: Mariano Salvador Maella, a prolific draughtsman; and Vicente López, who dominated the somewhat formal painstakingly exact portrait.

Federico Madrazo was a fine draughtsman, especially of graceful and spiritual portraits; admire his portrait of the great writer Larra, *Portrait of Mariano José de Larra, "Fíagro,"* (Museo de Arte Moderno), reproduced here.

To complete the selection, the two best Spanish painters of the nineteenth century after Goya are to be recalled, both unsuccessful, Mariano Fortuny and Eduardo Rosales, who were masterly draughtsmen of nudes.

The difficulties in selecting examples, demonstrating the greatest number of trends and technical processes, have made it necessary in some cases to show drawings of secondary quality; nevertheless, the series presented should afford a sufficiently clear and documented idea of "Spanish artistic diversity."

F. J. SÁNCHEZ CANTÓN
Director, Prado Museum

Madrid, May 1964

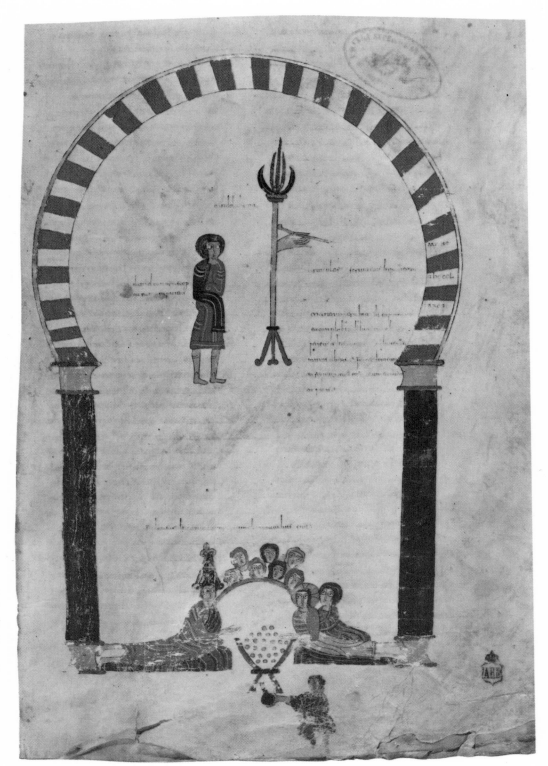

Plate 1
MONIUS and
EMETERIUS PRESBYTERUS
Belshazzar's Feast
A page from a manuscript
"Explanatio in Apocalypsis
S. Johannis" by San Beato
de Liévana, c. 970
Madrid, Archivo
Histórico Nacional

Plate 2

Spanish, 10th Century • *Drinkers,* from marginal illustrations of three pages of a manuscript, "Libellus Scintillae Scripturarum"
by Alvaro de Córdoba • Madrid, Real Academia de la Historia

Plate 3
Spanish, 13th Century
St. George and the Dragon (?)
from a Mozarabic Homily
manuscript
Madrid
Real Academia de la Historia

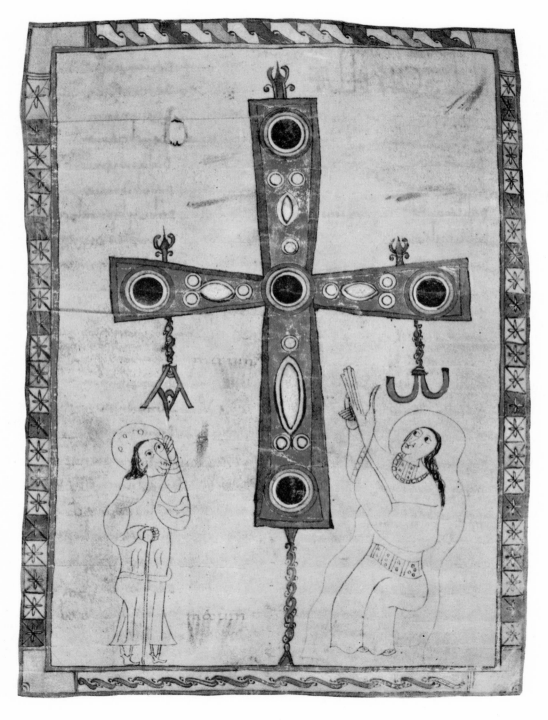

Plate 4
Spanish, 10th Century
Symbolic Crucifixion with Alpha and Omega
Page from a manuscript
"Libellus Scintillae Scripturarum"
by Alvaro de Córdoba
Madrid
Real Academia de la Historia

Plate 5
FACUNDUS
Initial A, from a
"Commentary on the Apocalypse," 1047
Madrid, Biblioteca Nacional

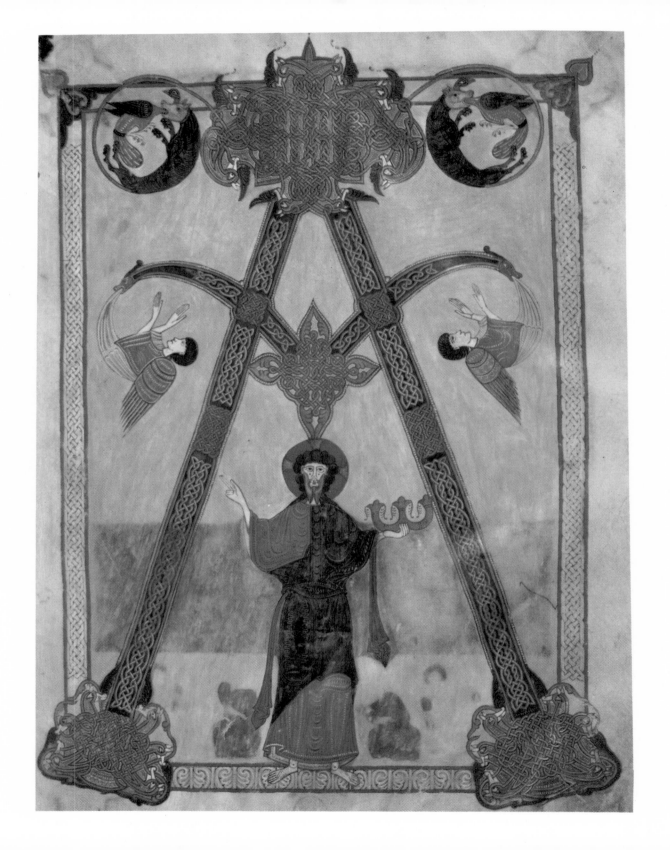

37

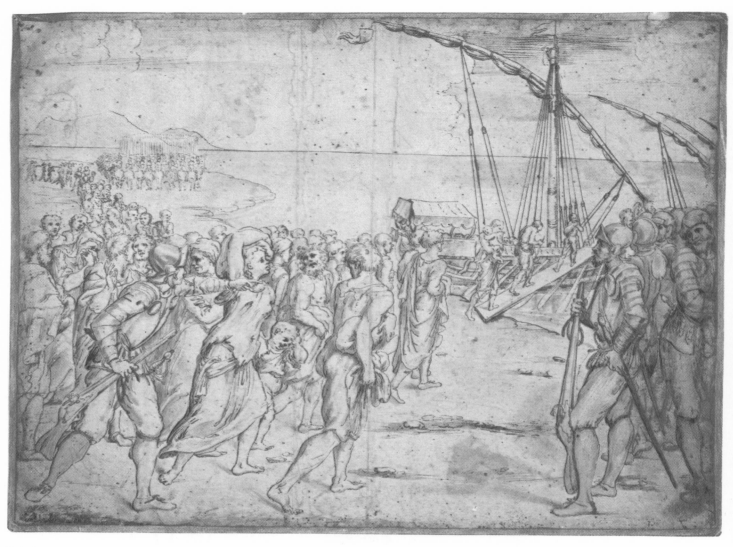

Plate 6
Vicente CARDUCHO • *The Expulsion of the Moors* • quill pen and washes, 14¹³⁄₁₆ x 19¹³⁄₁₆ inches • Madrid, Prado

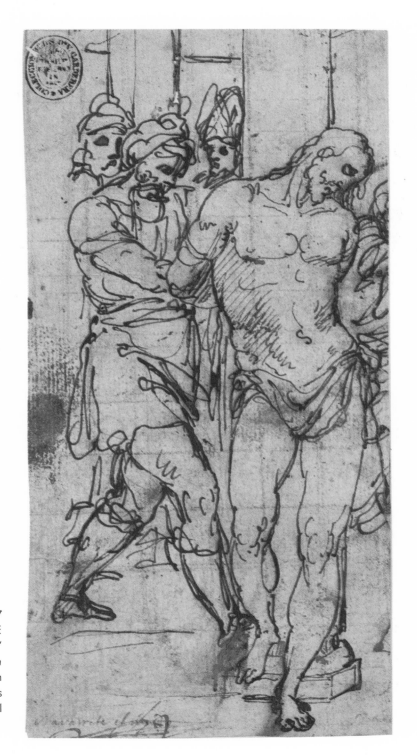

Plate 7
NAVARRETE
"El Mudo"
The Flagellation
quill pen
11 3/8 x 4 15/16 inches
Madrid, Biblioteca Nacional

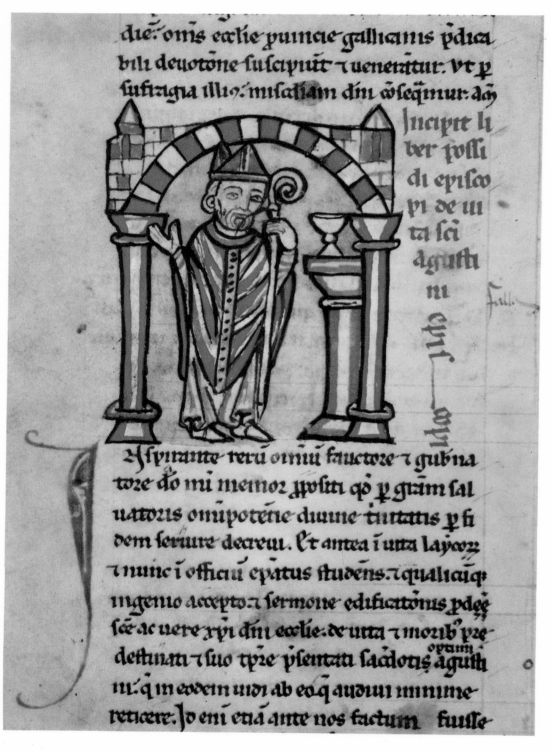

die: omis eæltie puincie gallianis pdica
bili deuotône suscipiut z uenenitur. ut p
sufitagia illog misatiam dni cosequimur ady

incipit li
ber postu
di episco
pi de ui
ta sci
agusti
ni
epist

Aspirante reru omniu fauctore z gubna
toze do mi memor postti co p gram sal
uatozis omipotétie diuine tinitatis p fi
dem seruire decreui. Et antea i utta laycoz
z nunc i officiu epatus studens. z qualiaciqs
mgenio accepto. z sermone edificationis pdeg
seé ac uere xpi dni ecclie. de utta z moub pre
destinati z suo tpze psentati sacdotis agusti
ni. qi in eodem uidi ab eoq audiui minime
reticere. Id eni etia ante nos factum fuisse

Plate 8
Spanish, 12th Century
Romanesque Columns and a Bishop
decoration from a manuscript
"Vitae Patrum Orientalium"
Madrid, Real Academia de la Historia

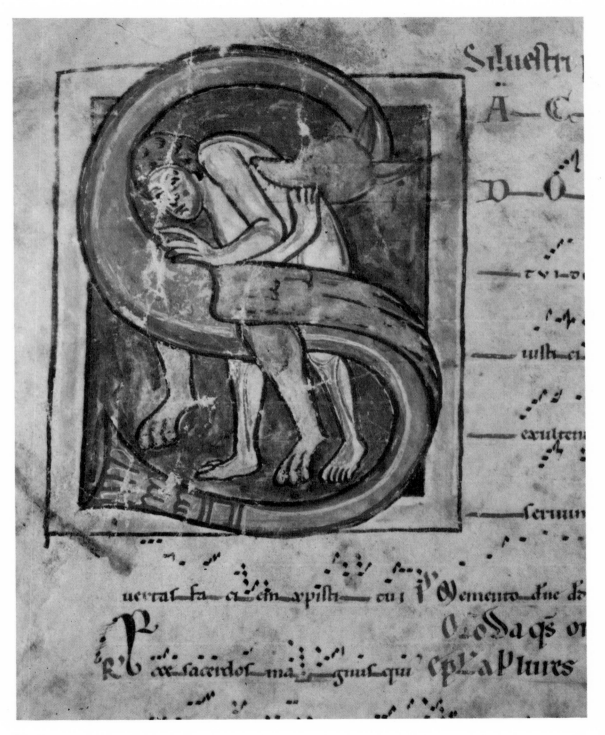

Plate 9
Spanish, 12th Century · *A Demon Biting a Sinner*, from a Choir Missal · Madrid, Real Academia de la Historia

Plate 10

Francisco PACHECO · *Portrait of The Doctor Bartolomé Hidalgo* · quill pen with sanguine, 13⅜ x 10³⁄₁₆ inches · Madrid, Museo Lázaro Galdiano

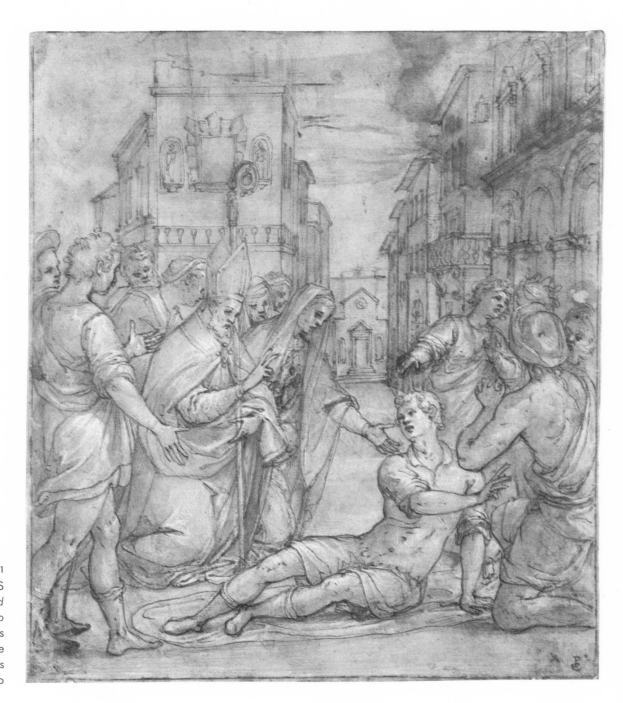

Plate 11
Pablo de CESPEDES
St. Hermengild
Blessed by a Bishop
quill pen with sepia washes
and touches of white
11¹¹⁄₁₆ x 9½ inches
Madrid, Prado

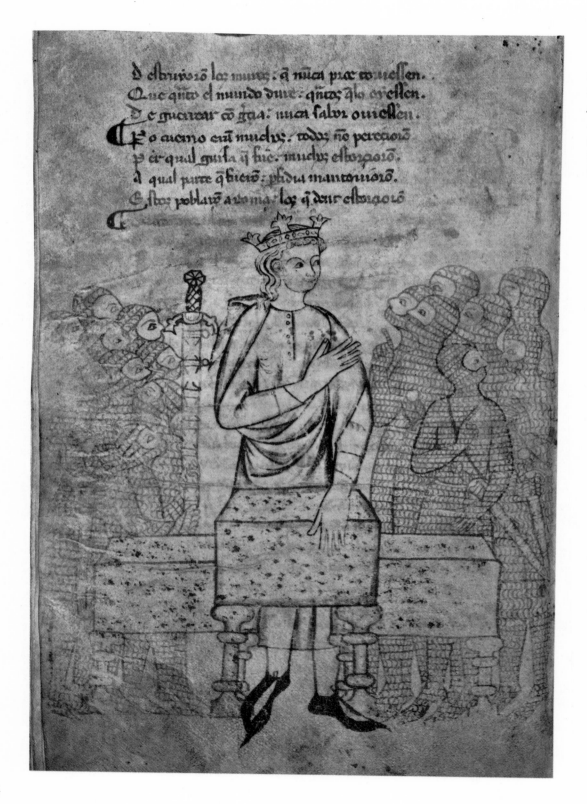

Plate 12
Spanish, 13th Century
Alexander the Great with his Armies, illustration from a poem, "Libre de Alexandre"
Madrid
Biblioteca Nacional

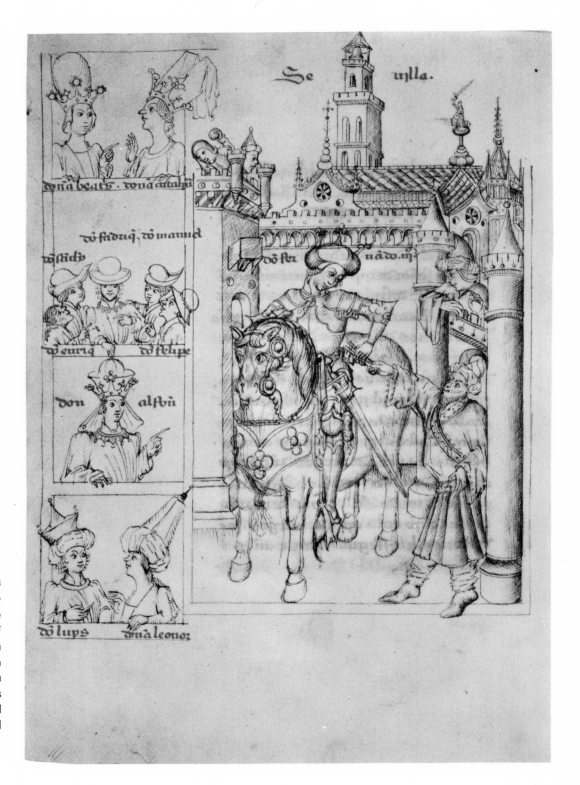

Plate 13
Spanish, 13th Century
*A page showing
Ferdinand III at the gates of
Seville,* from "Genealogia
de los Reyes," by Don
Alonso de Cartagena
the Bishop of Burgos
Madrid
Biblioteca del Palacio Real

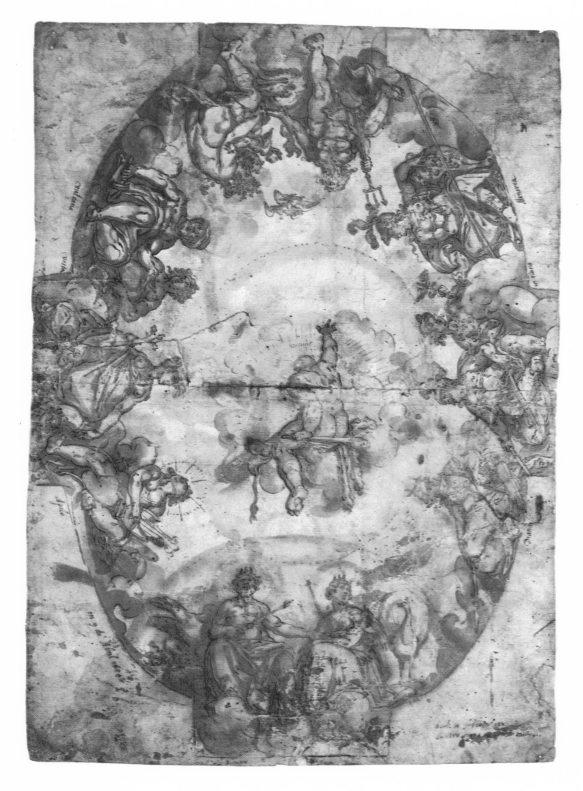

Plate 14
Francisco PACHECO
Ceiling design for La Casa de Pilatos, Seville
signed April 9, 1604
quill pen with sepia tints
15⅜ x 11⅜ inches
Madrid, Real Academia de Bellas Artes de San Fernando

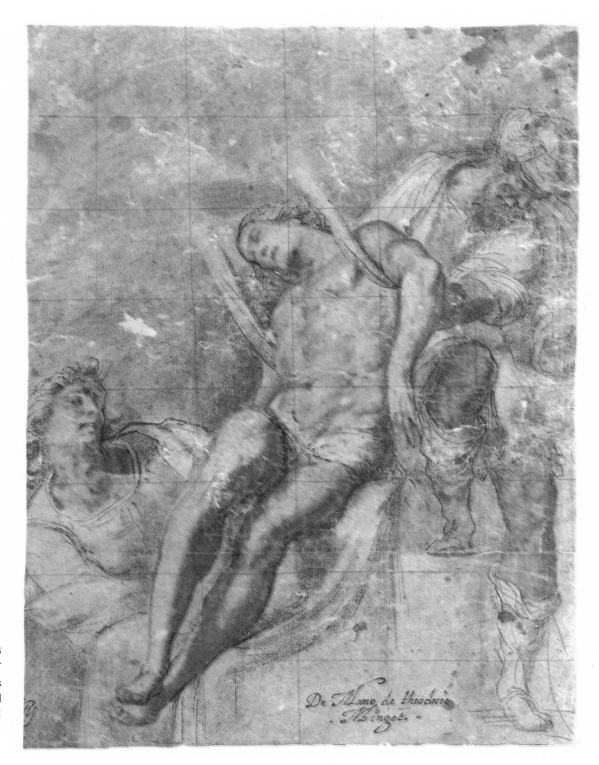

Plate 15
Teodosio MINGOT
Descent from the Cross
Madrid
Biblioteca del Palacio Real

47

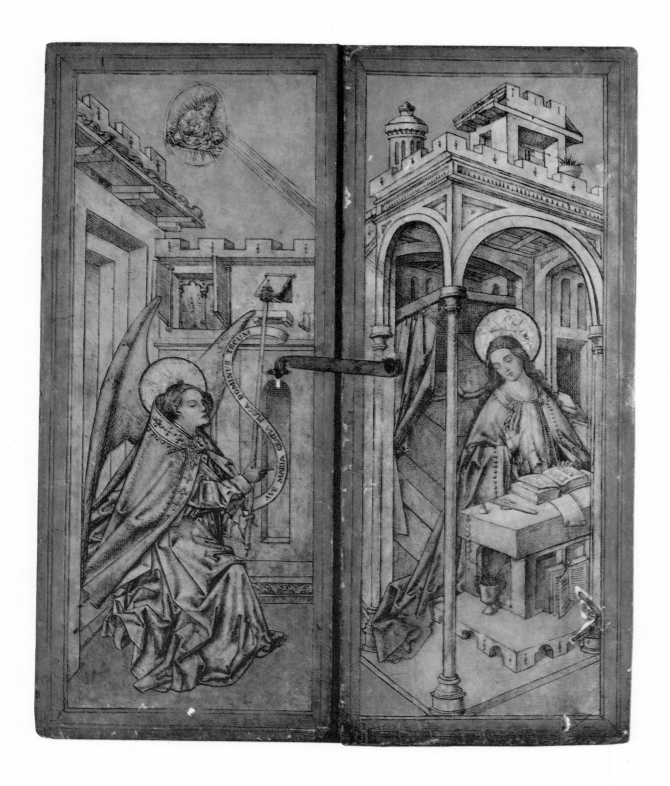

Plate 16
Spanish, 13th Century
The Annunciation, 1470-75
Drawn on the outside panels of
a triptych
Madrid, Museo Lázaro Galdiano

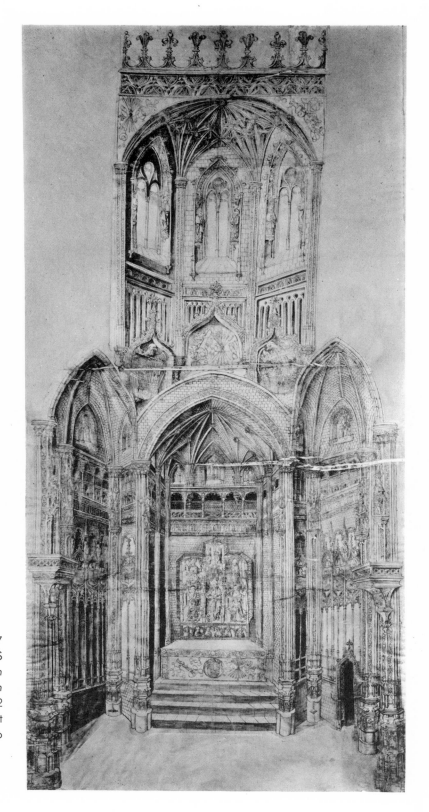

Plate 17
Juan GUAS
*Project for a retable in the main
chapel of the Church of San Juan
de los Reyes, Toledo, about 1482
quill pen on parchment*
76½ x 37¾ inches • Madrid, Prado

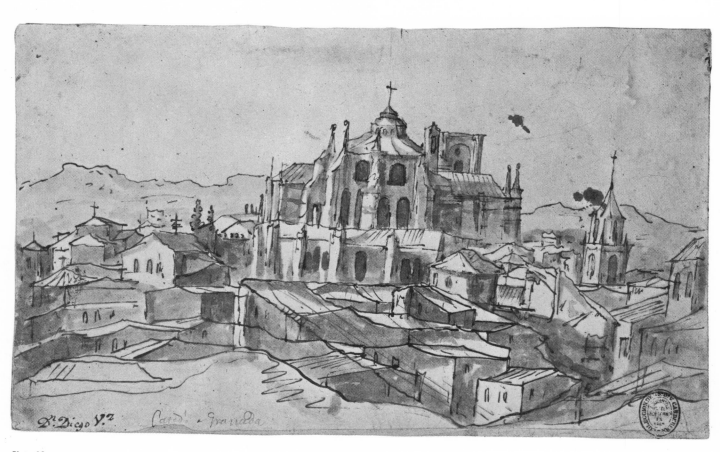

Plate 18

Diego VELAZQUEZ • *View of the Cathedral of Granada* • quill pen with thin washes of India ink, 7¾₁₆ x 12⅛ inches
Madrid, Biblioteca Nacional

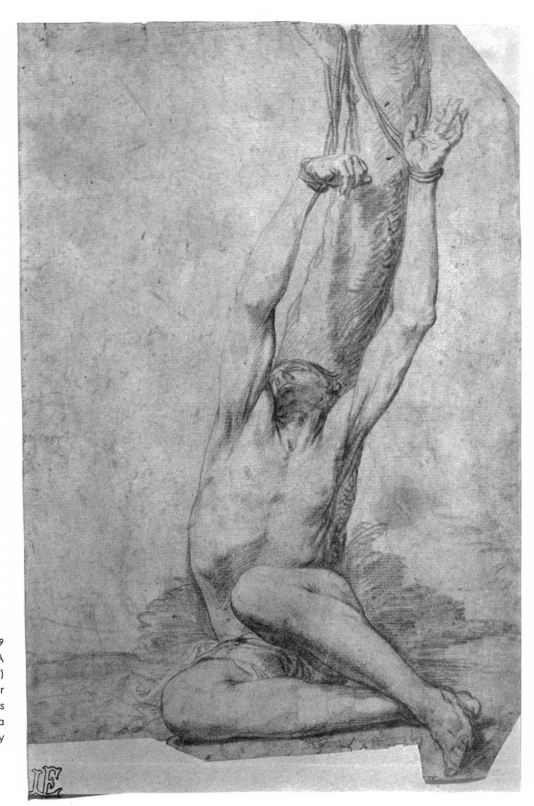

Plate 19
Jusepe de RIBERA
Martyrdom of a Saint (St. Sebastian?)
red chalk on brown paper
10 1/16 x 6 3/8 inches
Bloomington, Indiana
Indiana University

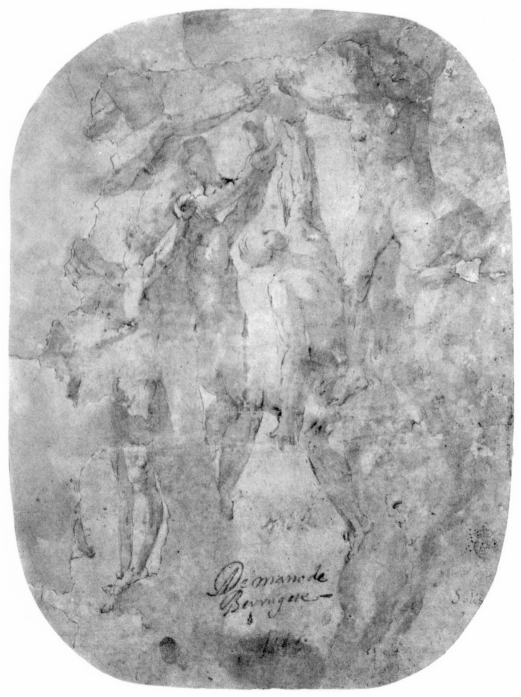

Plate 20
Alonso BERRUGUETE
Studies for a Crucifixion
quill pen with sepia wash
12⅞ x 8¹³⁄₁₆ inches
Madrid, Real Academia de Bellas
Artes de San Fernando

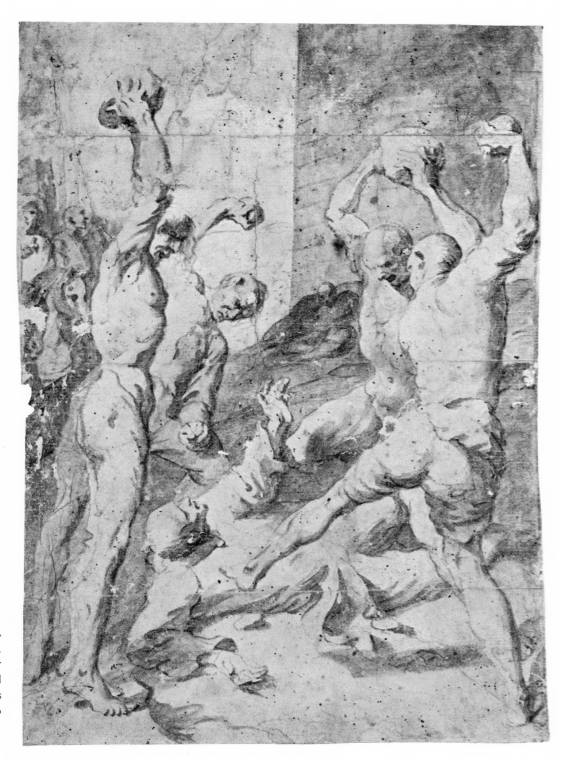

Plate 21
Francisco RIBALTA
The Stoning of St. Stephen,
Deacon and Martyr
red washes and pencil
9⅝ x 6¹¹⁄₁₆ inches
Madrid, Prado

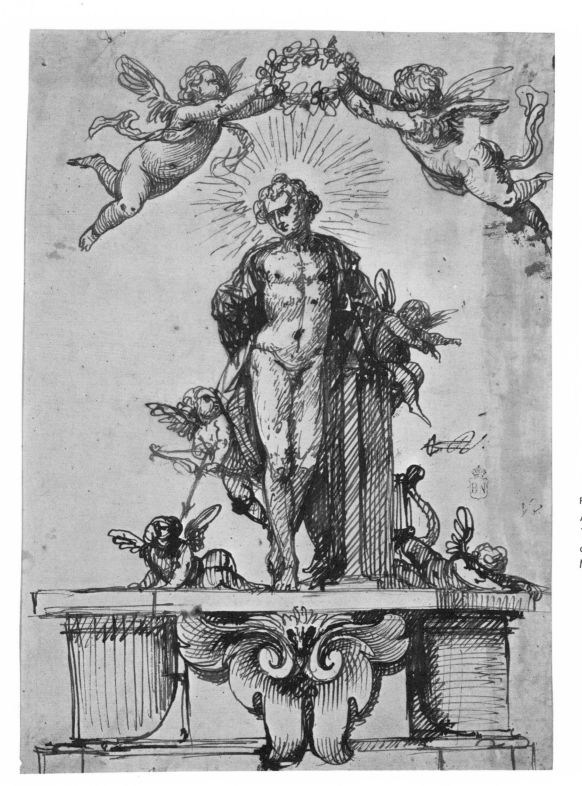

Plate 22
Alonso CANO
Triumph of Apollo
quill pen, 11½ x 5½ inches
Madrid, Biblioteca Nacional

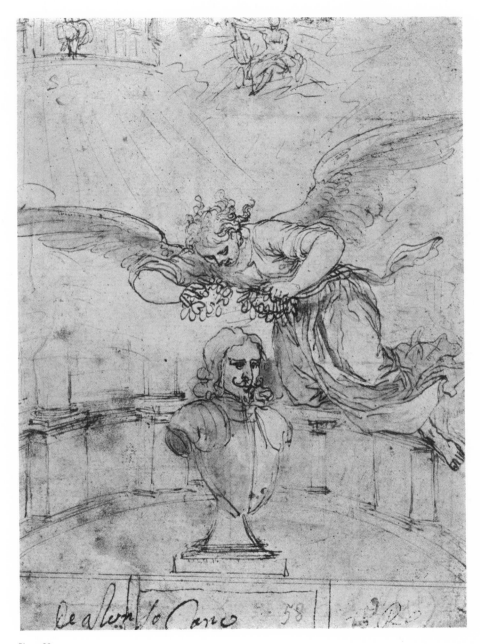

Plate 23

Alonso CANO • *Victory Crowning the Soldier-Poet* • quill pen with sepia washes
6¹¹⁄₁₆ x 4¾ inches • Madrid, Prado

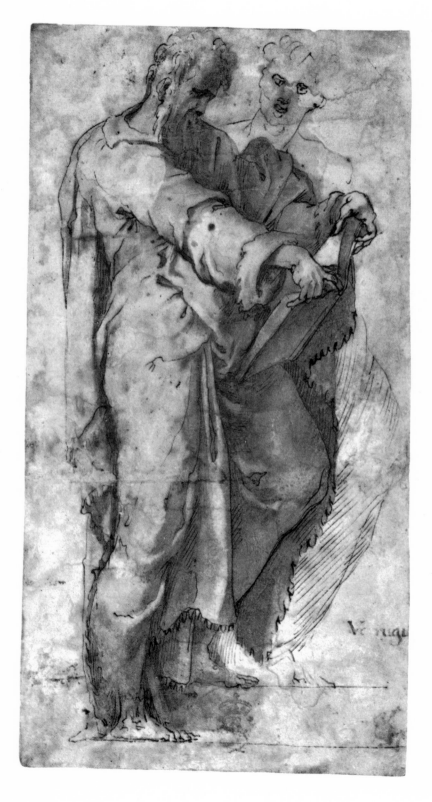

Plate 24

Alonso BERRUGUETE
An Apostle
quill pen with sepia wash
8⅛ x 4¼ inches
Madrid, Real Academia de Bellas
Artes de San Fernando

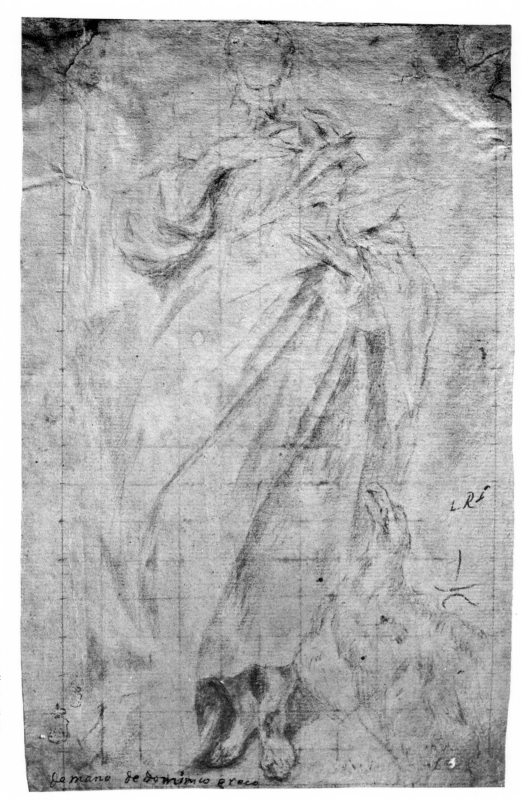

Plate 25
El GRECO
St. John the Evangelist
black chalk with touches of
white; entire drawing very faint
11⅜ x 6¹¹⁄₁₆ inches
Madrid, Biblioteca Nacional

57

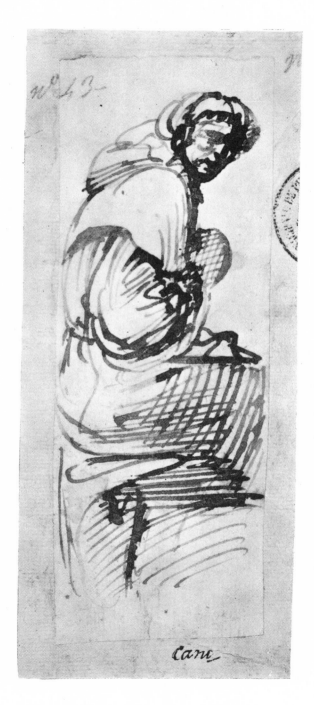

Plate 26
Alonso CANO
*Study for the Figure of a
Franciscan Monk*
pen and ink, 6 15/16 x 2 15/16 inches
Madrid, Prado

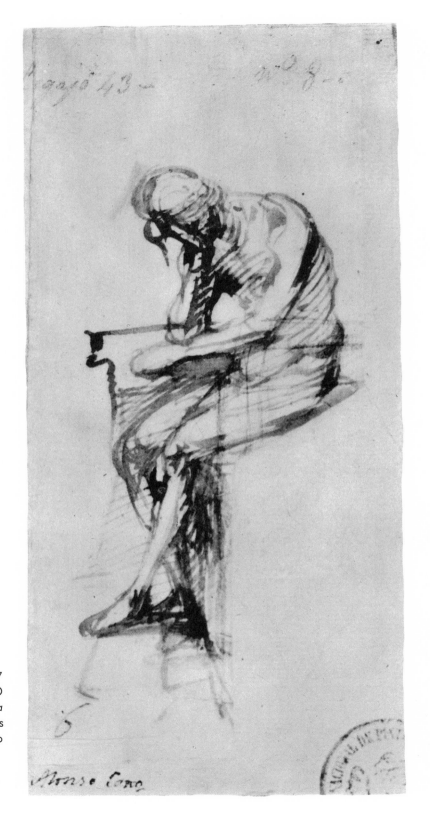

Plate 27
Alonso CANO
Study for El Cristo de la Paciencia
pen and ink, 6⅞ x 3⅜ inches
Madrid, Prado

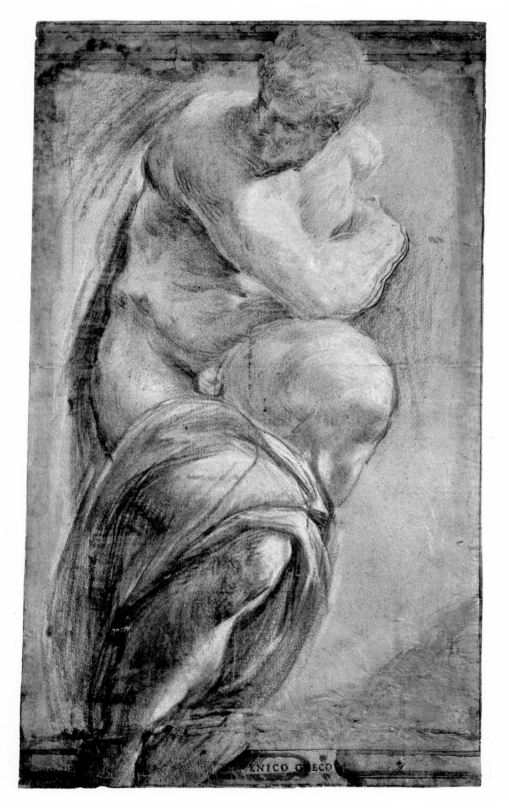

Plate 28
EI GRECO
Copy after
Michelangelo's "Day"
black and white chalk with
blue tint on the edges,
on blue paper turned yellow
23½ x 13⅝₆ inches
Munich, Staatliche
Graphische Sammlung

Plate 29
Diego VELAZQUEZ (?)
Portrait of a Girl
black chalk on blue-gray
paper, heightened with
white, 10⅞ x 7⅜ inches
London, The British Museum

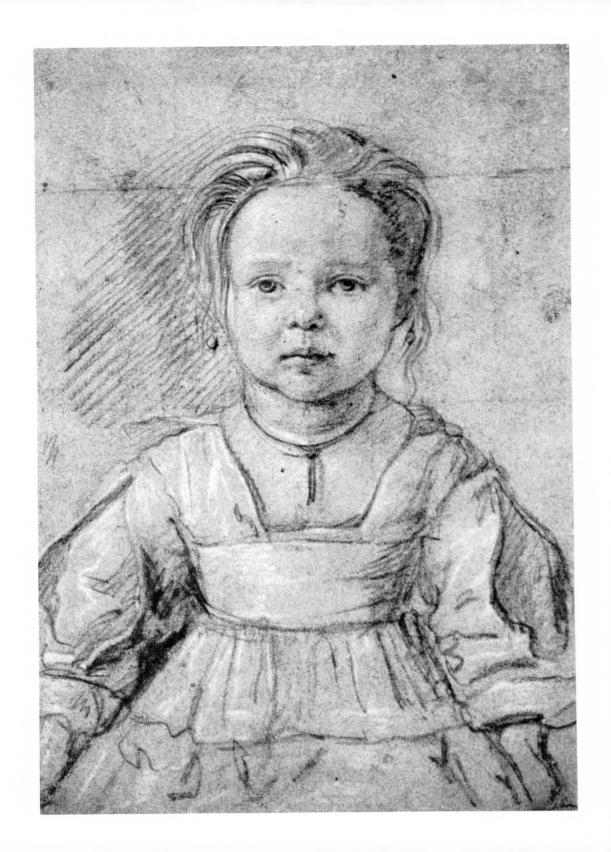

61

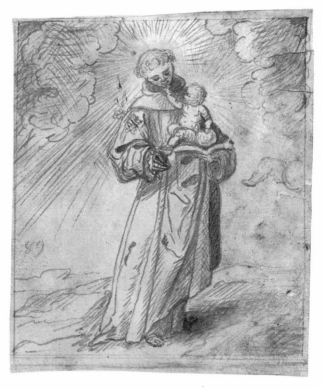

Plate 30
Alonso CANO • *St. Anthony Abbot* • pen and ink
3⅞ x 3¼ inches • Madrid, Biblioteca Nacional

Plate 31
Diego VELAZQUEZ
Study of horse for "Surrender at Breda"
pierre noir, 9⅞ x 7½ inches, Paris, Louvre

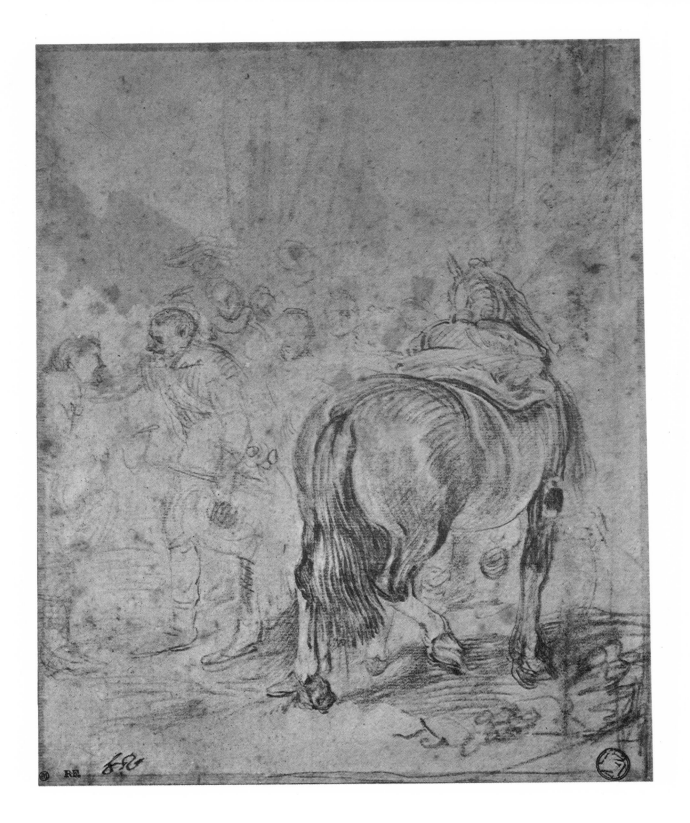

63

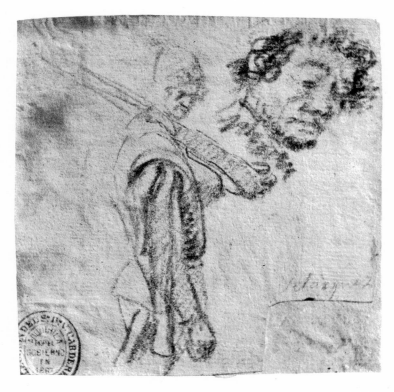

Plate 32
Diego VELAZQUEZ · *Soldier in Profile, Marching with a Musket on His Arm* · pencil,
3¾ x 3¹¹⁄₁₆ inches · Madrid, Biblioteca Nacional

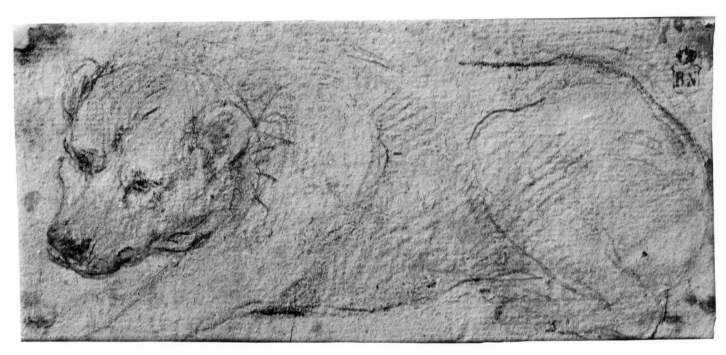

Plate 33
Diego VELAZQUEZ (?) • *A Dog* • pencil, 3½ x 7⅜ inches • Madrid, Biblioteca Nacional

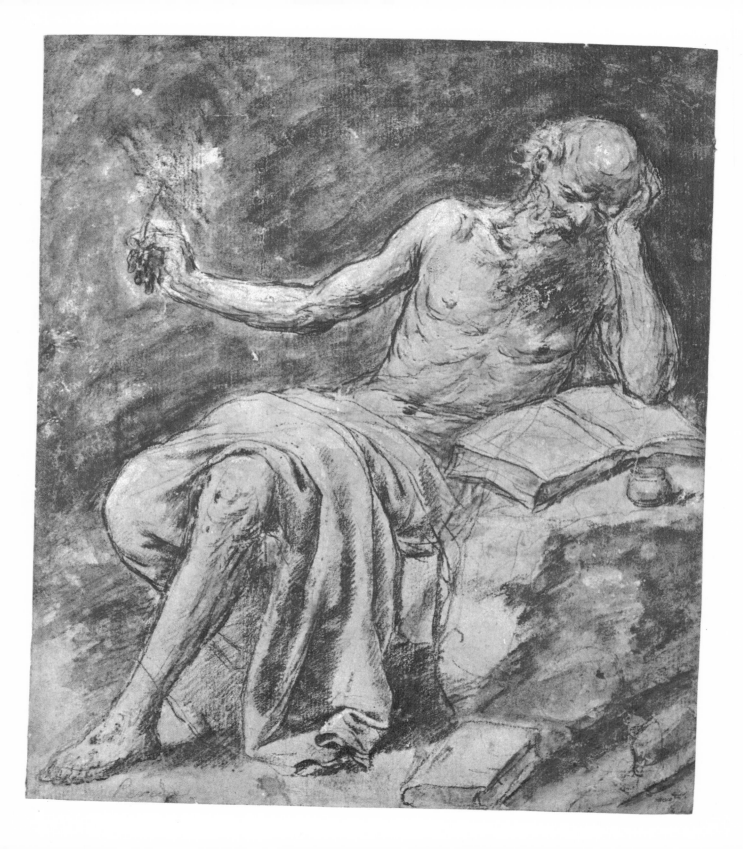

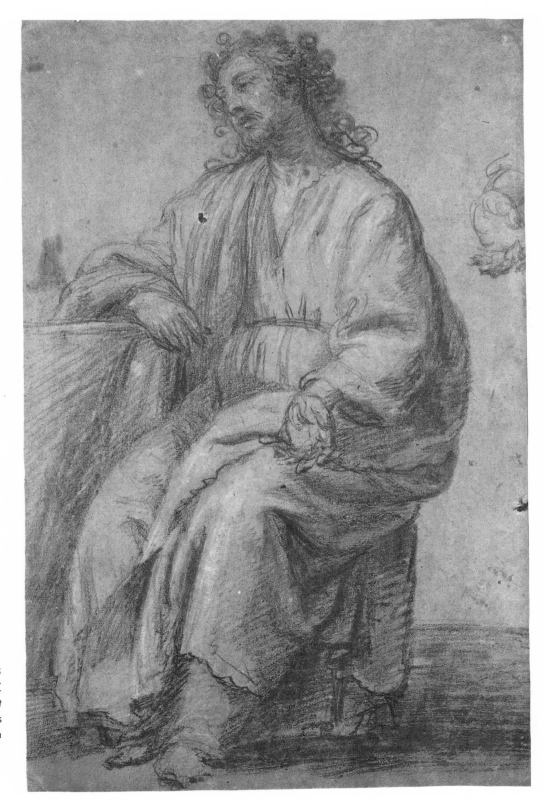

Plate 34
Antonio de PEREDA
St. Jerome Writing
black chalk with touches
of red chalk, 9 15⁄16 x 8½ inches
London, The British Museum

Plate 35
Diego VELAZQUEZ
Study for a Seated Christ
black chalk, 15¼ x 9¾ inches
New York, Wildenstein

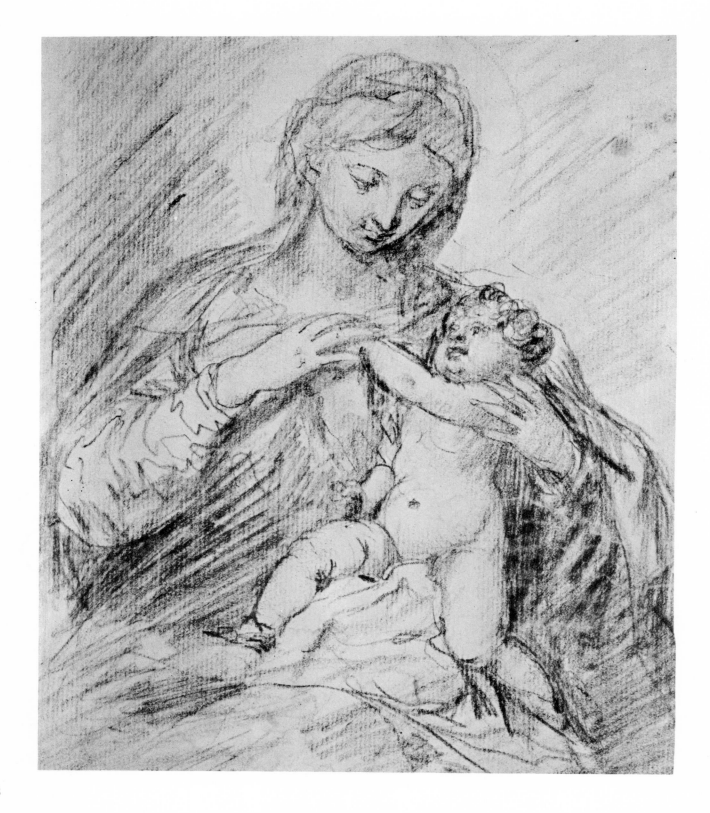

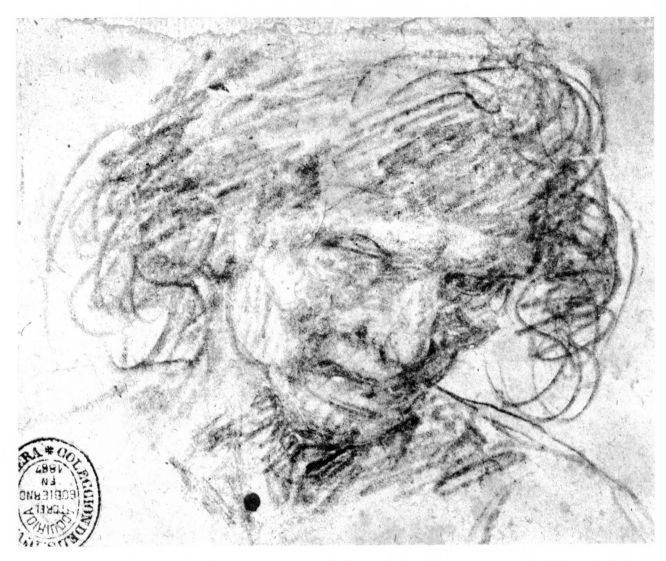

Plate 37
Diego VELAZQUEZ · *Head of a Man* · black chalk and wash, 5⅞ x 6⅝ inches · Madrid, Biblioteca Nacional

Plate 36
Alonso CANO
The Virgin and the Infant Christ (detail)
black chalk, 9¼ x 6⅞ inches, Madrid, Prado

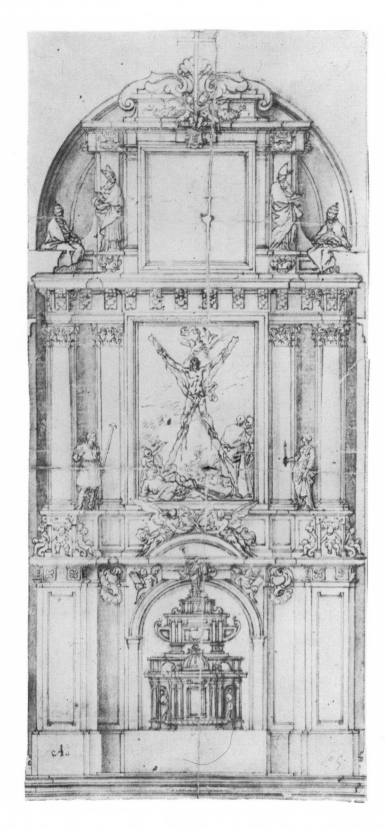

Plate 38
Alonso CANO
Project for a Retable for the
Church of San Andrés in Madrid
pen, ink and wash in sepia
11¼ x 4¾ inches, Madrid, Prado

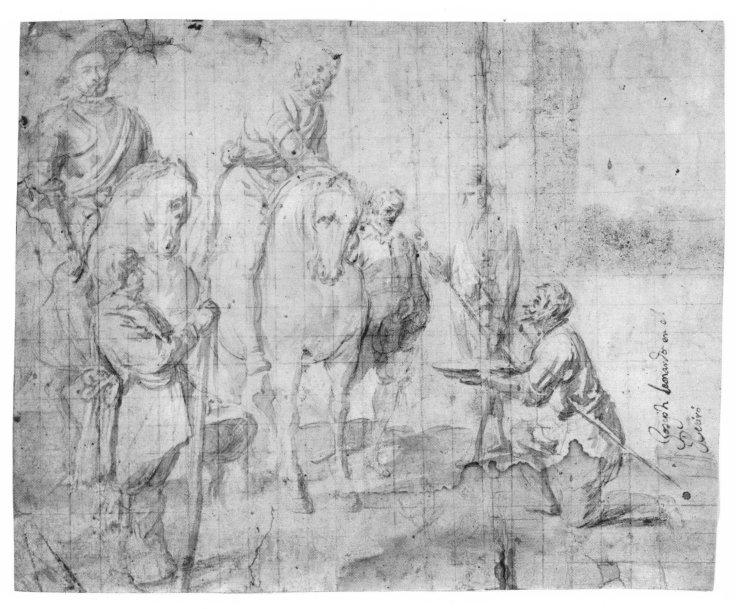

Plate 39
Jusepe LEONARDO · *The Surrender of Juliers to the Marquis of Spinola* (Surrender at Breda) · thin washes of sepia, 10¼ x 8¼ inches
Madrid, Prado

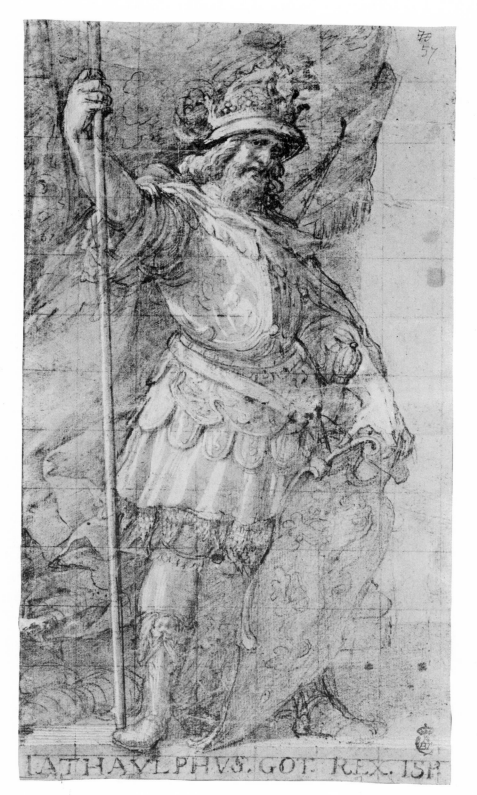

LATHAVLPHVS. GOT. REX. ISP

Plate 41
Juan CARRENO
Portrait of a Man
black and red pencil, 8⅜₁₆ × 6⅛ inches
Madrid, Prado

Plate 40
Vicente CARDUCHO
Ataulfo, Visigothic King of Spain
pencil with white touches
on blue paper, 15⅝₁₆ × 8⅝ inches
Madrid, Real Academia de Bellas
Artes de San Fernando

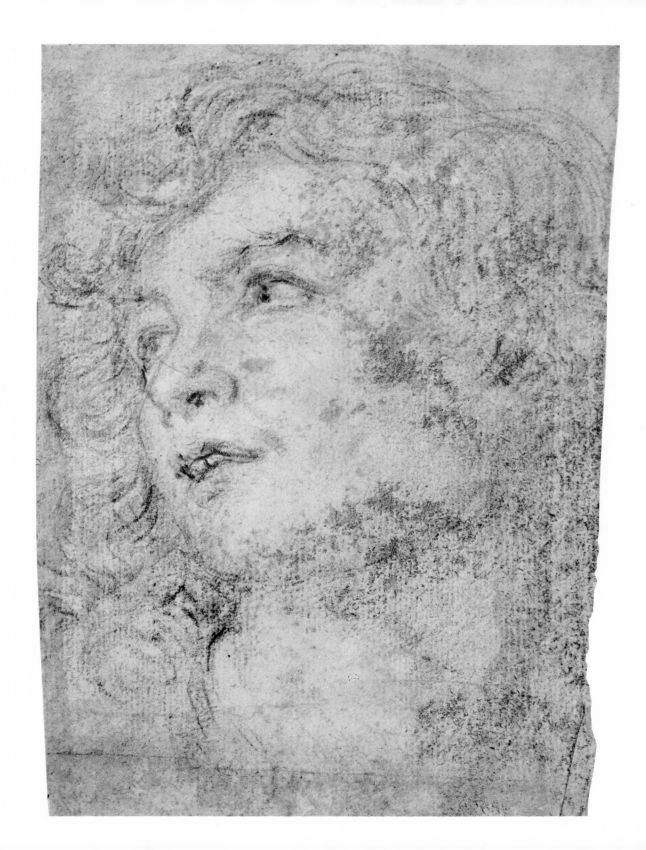

73

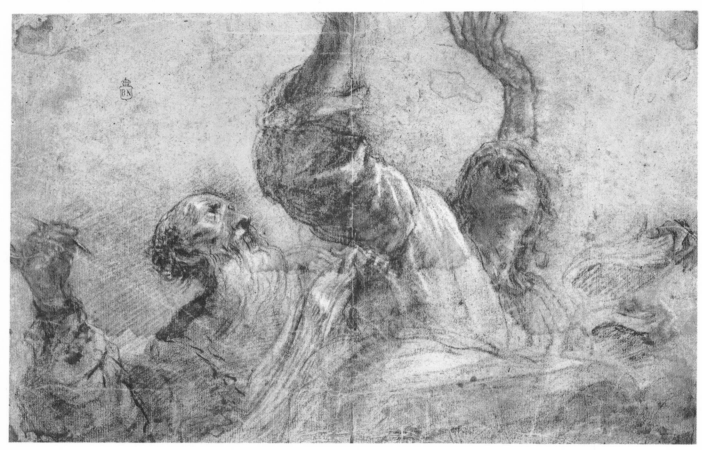

Plate 42
Juan CARRENO • *Two Apostles* • black, red and white chalks on yellowish paper, 10¹⁄₁₆ x 15½ inches • Madrid, Biblioteca Nacional

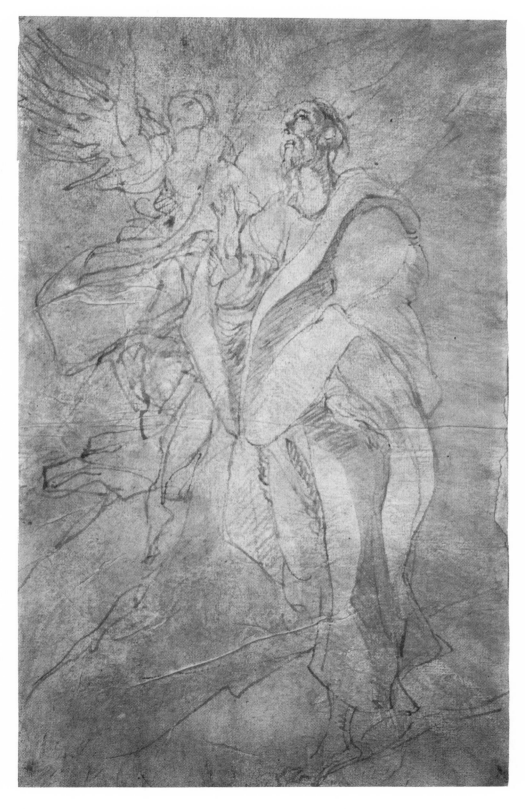

Plate 43

El GRECO
St. John the Evangelist
pen and wash
13¼ x 8¼ inches
New York, Wildenstein

75

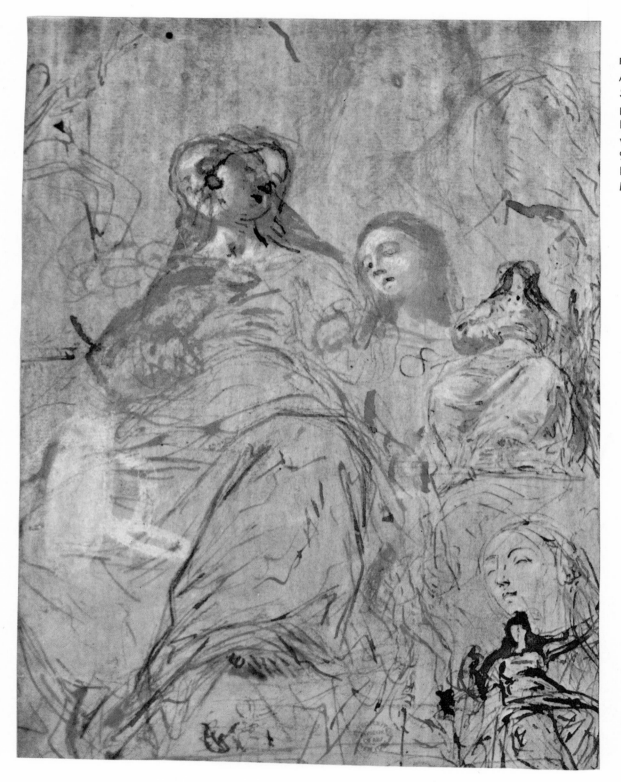

Plate 44
Attributed to Juan CARRENO
Studies for a Madonna
pen and brown ink
heightened with
white gouache
9⅜ x 7½ inches
New York, The
Metropolitan Museum of Art

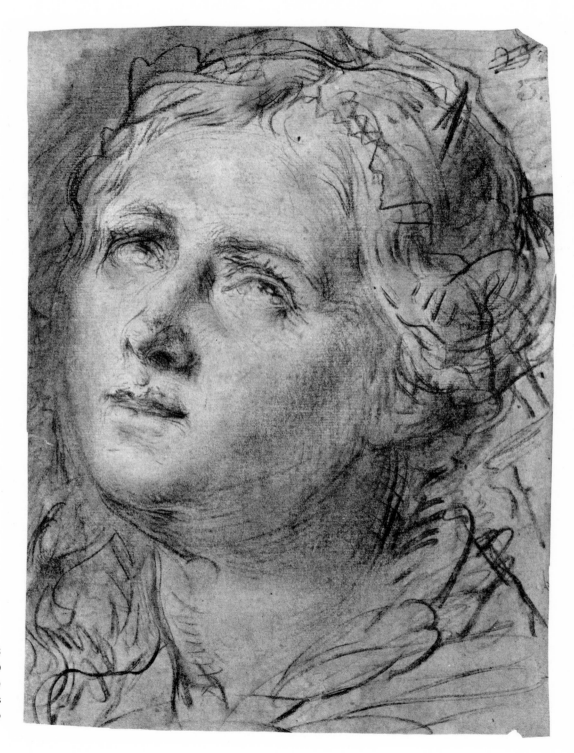

Plate 45
Juan CARRENO
Head of a Woman
pencil, 9⁵⁄₁₆ x 7⅛ inches
Madrid, Prado

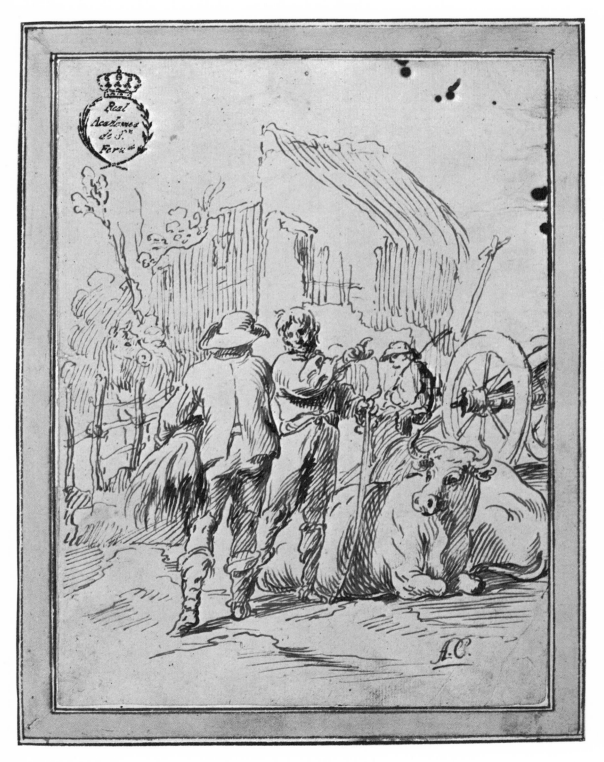

Plate 46
Antonio del CASTILLO
A Group of Farm Hands
quill pen, 7 15/16 x 5 5/16 inches
Madrid, Real Academia
de Bellas Artes
de San Fernando

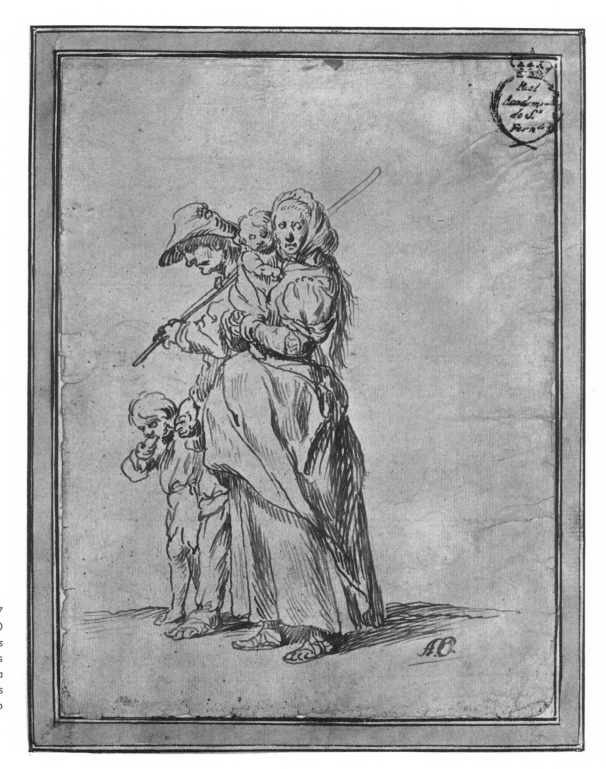

Plate 47
Antonio del CASTILLO
Family Group of Laborers
quill pen, 7¹⁵⁄₁₆ x 5⁵⁄₁₆ inches
Madrid, Real Academia
de Bellas Artes
de San Fernando

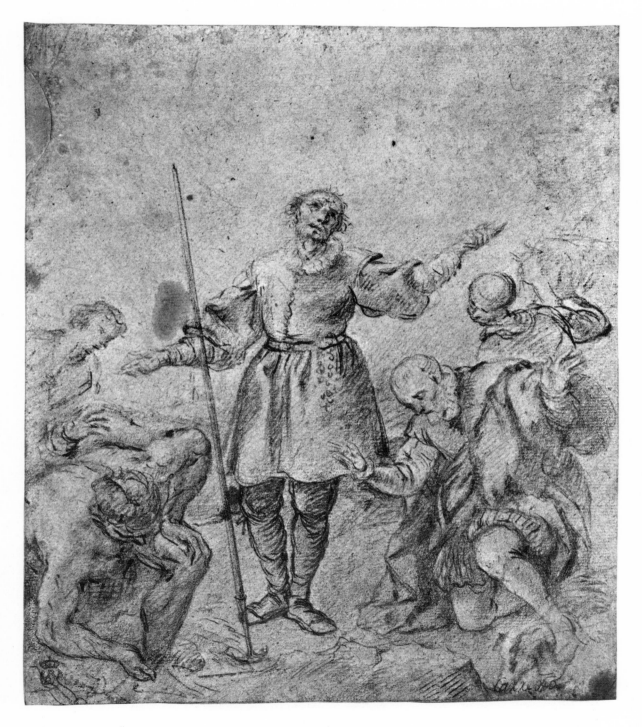

Plate 48
Juan CARRENO
St. Isidore the Tiller
pencil with sanguine
12¹⁵⁄₁₆ x 10¹⁵⁄₁₆ inches
Madrid, Real Academia
de Bellas Artes
de San Fernando

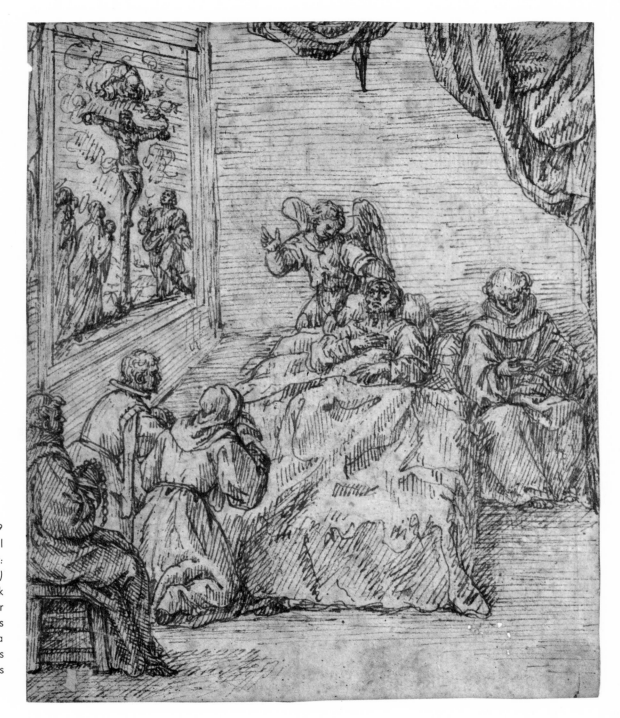

Plate 49
VALDES Leal
Death of a Franciscan Saint:
San Diego de Alcalá (?)
pen and ink
on medium tan paper
7⁵⁄₁₆ x 6 inches
Norfolk, Virginia
Norfolk Museum of Arts
and Sciences

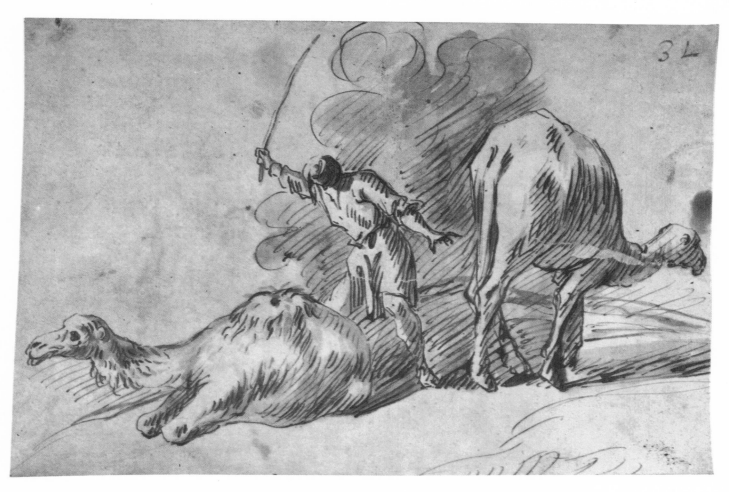

Plate 50
Antonio del CASTILLO · *Camels* · quill pen, 6⅝ x 9⅞ inches · Madrid, Prado

Plate 51
Bartolomé MURILLO
St. Felix of Cantalice Holding the Christ Child
pen and brown ink, and some brown wash
heightened with white, over preliminary
indications in black chalk, 13 x 9⅛ inches
New York, The Pierpont Morgan Library

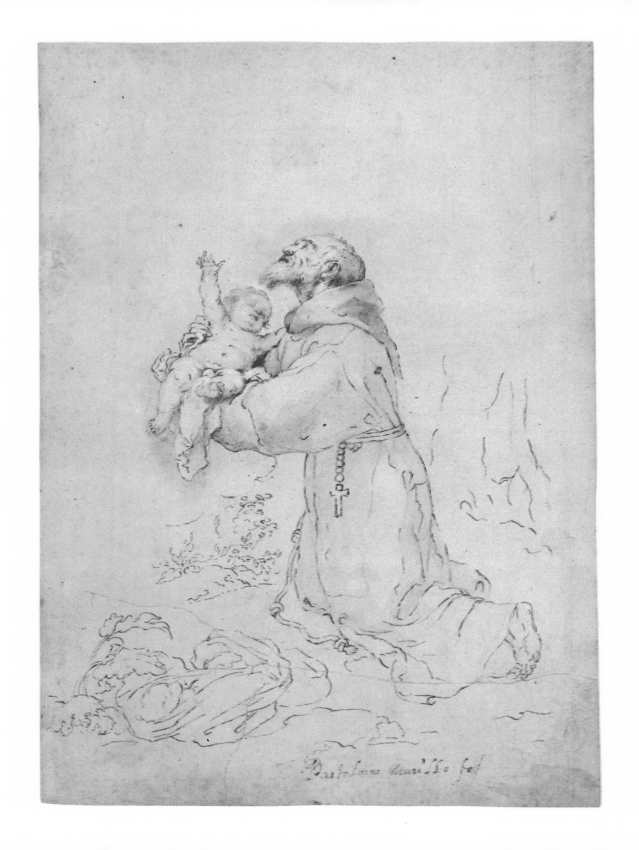

Bartolome Murillo fel

83

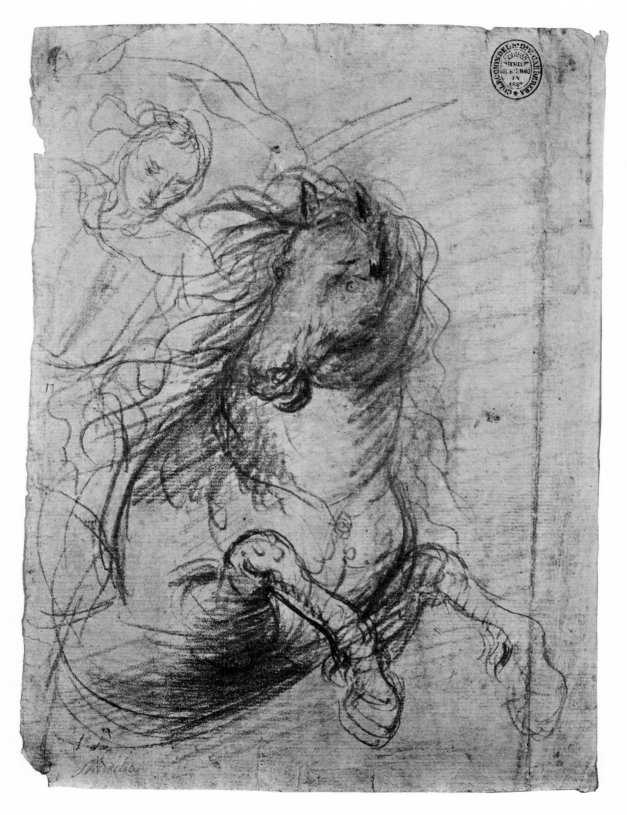

Plate 52
Bartolomé MURILLO (?)
Rider and Galloping Horse
black chalk
10 13/16 x 7 7/8 inches
Madrid, Biblioteca Nacional

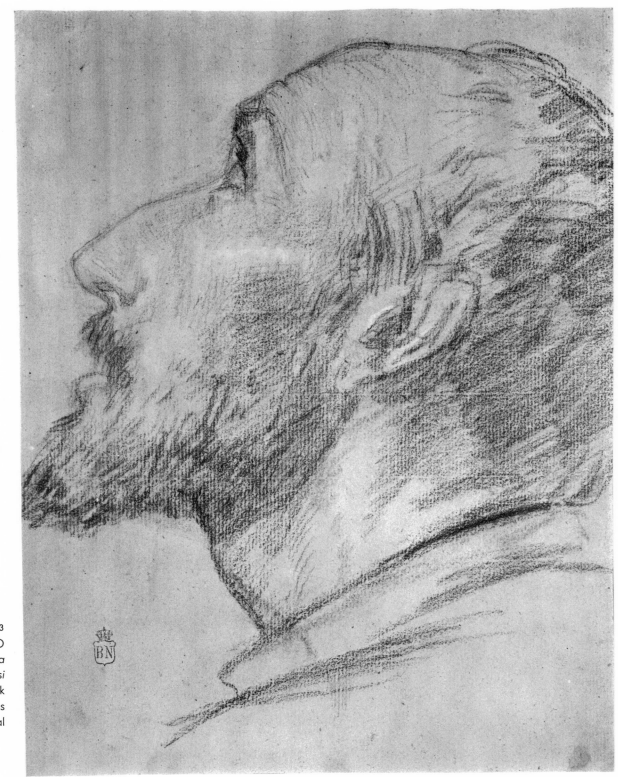

Plate 53
Bartolomé MURILLO
Study for a
St. Francis of Assisi
black and white chalk
10¹⁵⁄₁₆ × 8⅝ inches
Madrid, Biblioteca Nacional

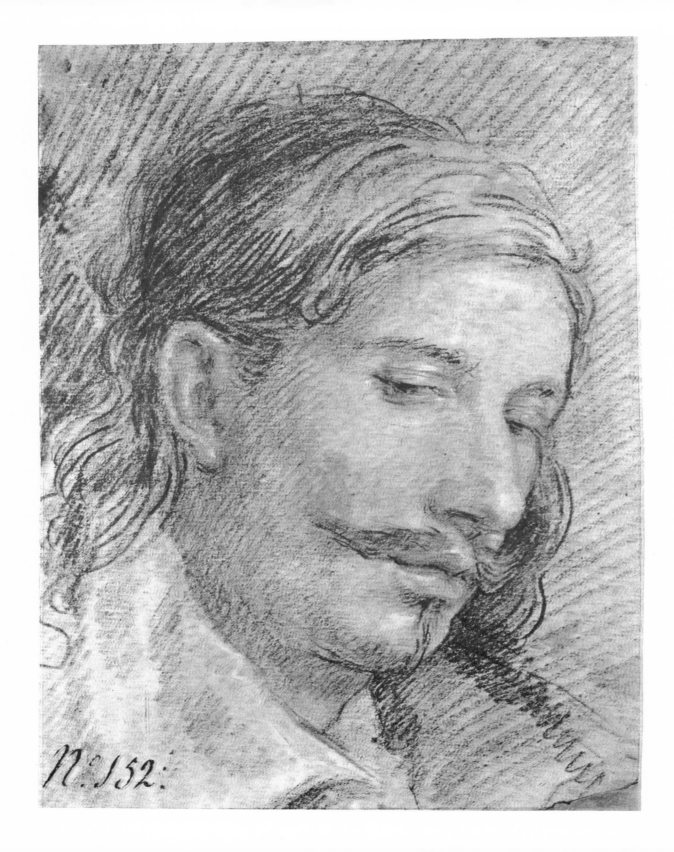

N.º 152:

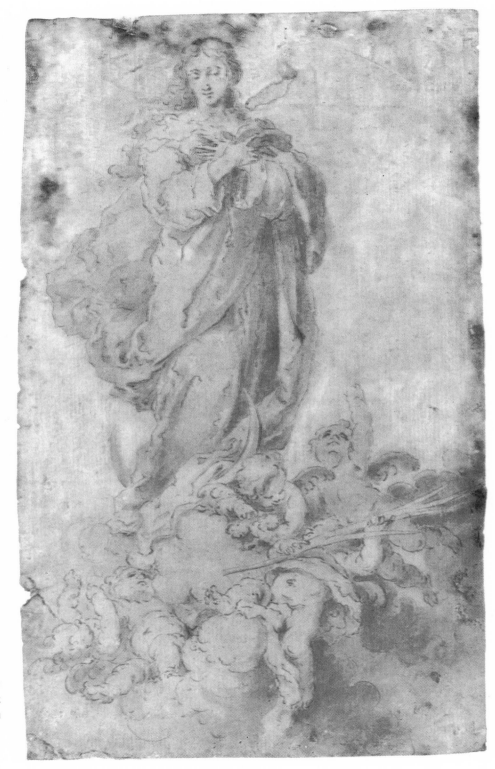

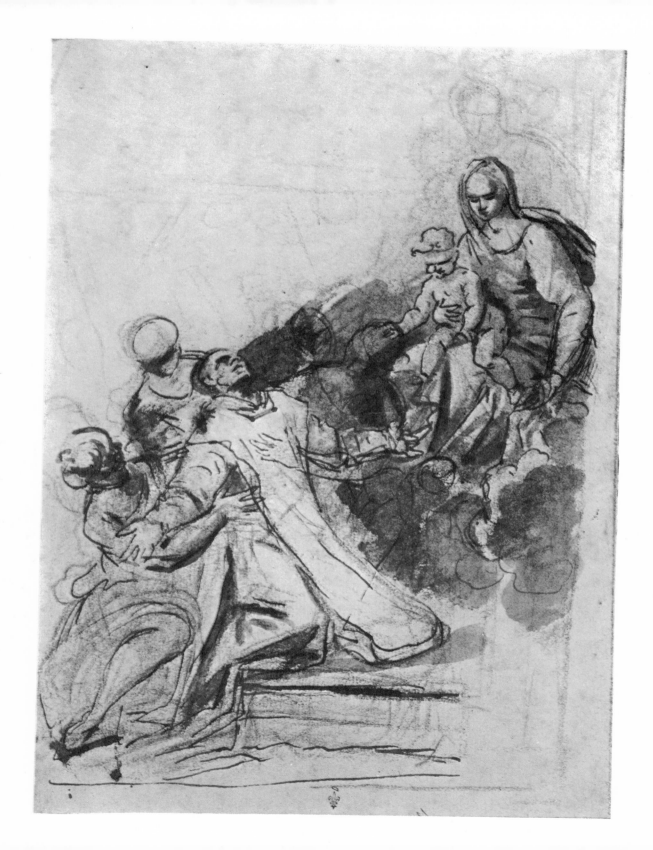

Plate 56
Bartolomé MURILLO
An Apparition of the Virgin and Child
to a Monk in Ecstasy
black ink with wash over chalk
9 11⁄16 x 7 inches
Chantilly, Musée Condé

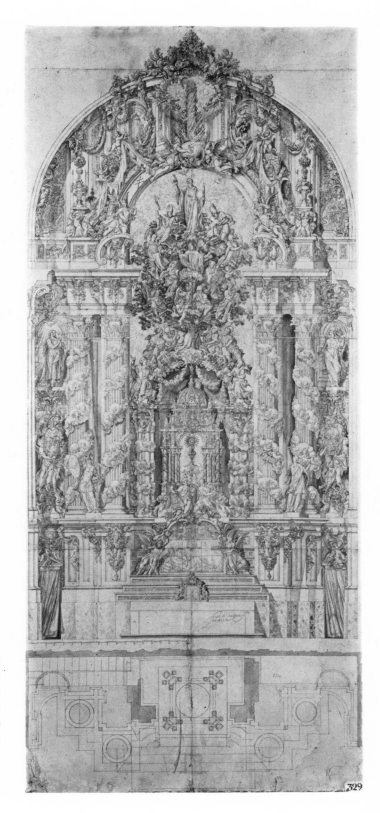

Plate 57
José CHURRIGUERA
Project for a retable
quill pen and washes
65⅜ x 27¾ inches
Madrid, Real Academia de Bellas
Artes de San Fernando

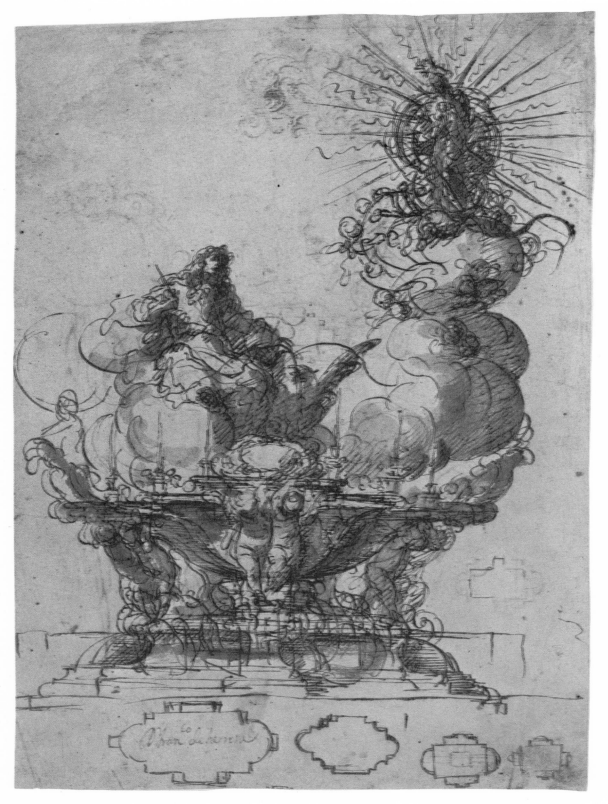

Plate 58
HERRERA
"El Mozo"
*Study for a Processional
Float: The Vision of St. John
on Patmos*
pen with brown ink and
brown wash, over
preliminary indications in
metal point
10¾ x 7¹³⁄₁₆ inches
New York
The Pierpont Morgan Library

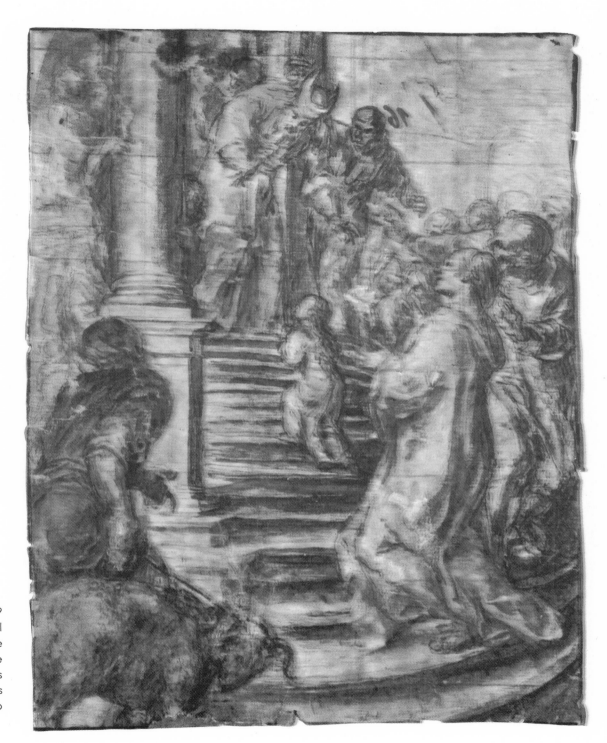

Plate 59
VALDES Leal
Presentation of the
Virgin Mary to the Temple
pencil and washes
8⅞ x 6⁵⁄₁₆ inches
Madrid, Prado

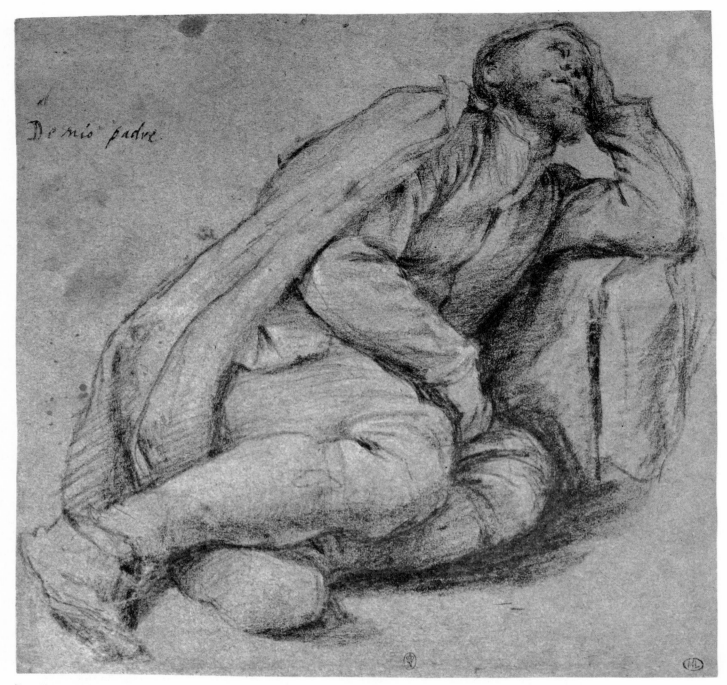

Plate 60

Ascribed to MURILLO · *Sleeping Man* · black crayon on blue paper, 8 1/16 x 8 1/4 inches · Paris, Louvre

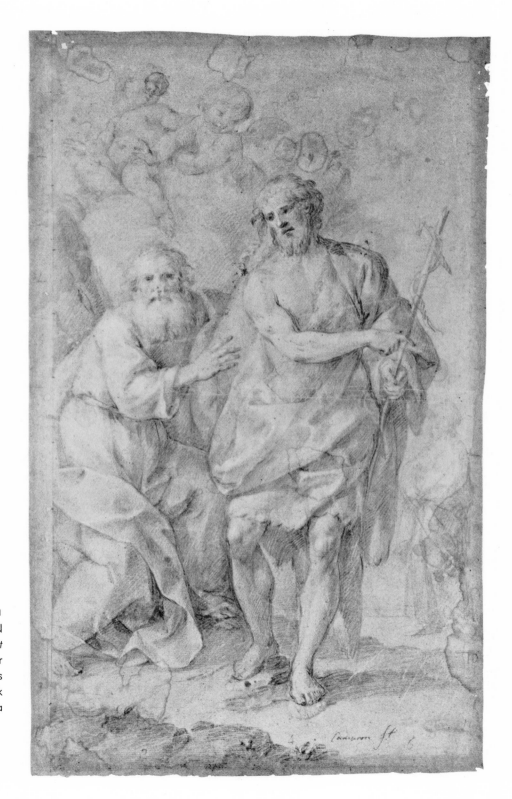

Plate 61
José CAMARON
St. John the Baptist
pencil on blue paper
21 ¹³⁄₁₆ x 12 ¹³⁄₁₆ inches
New York
The Hispanic Society of America

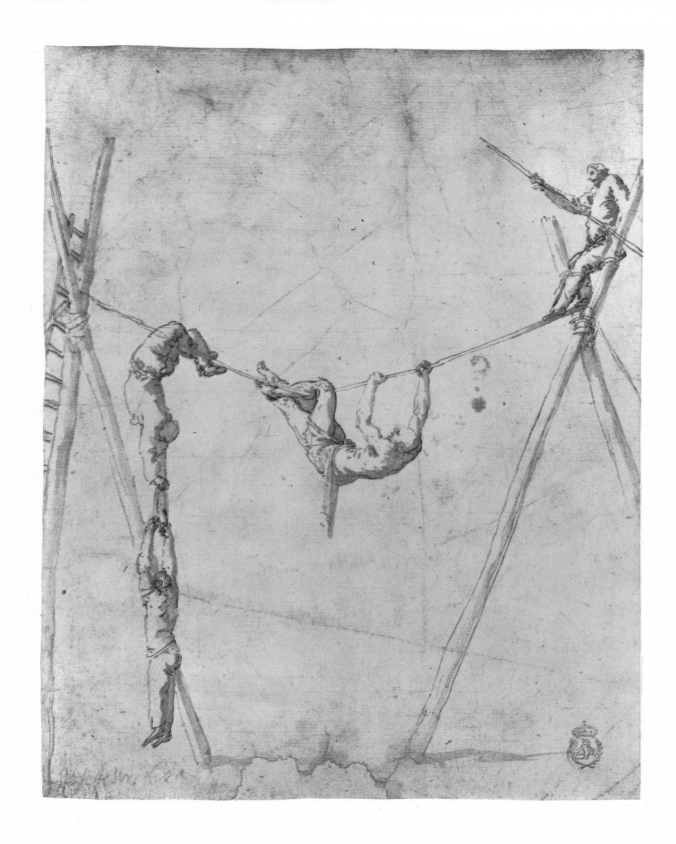

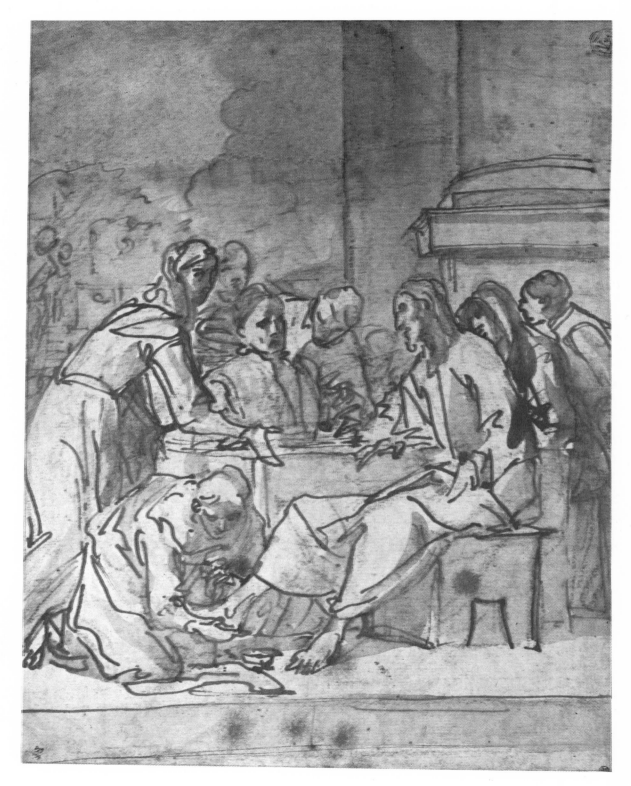

Plate 62
Jusepe de RIBERA
Acrobats
quill pen with very light
washes, 10¹⁄₁₆ x 7³⁄₄ inches
Madrid, Real Academia
de Bellas Artes
de San Fernando

Plate 63
Jusepe de RIBERA
Mary Magdalene
perfuming the feet of Christ
pen and ink with
bistre washes on the
pierre noir outline
9³⁄₁₆ x 7¹⁄₄ inches
Paris, Louvre

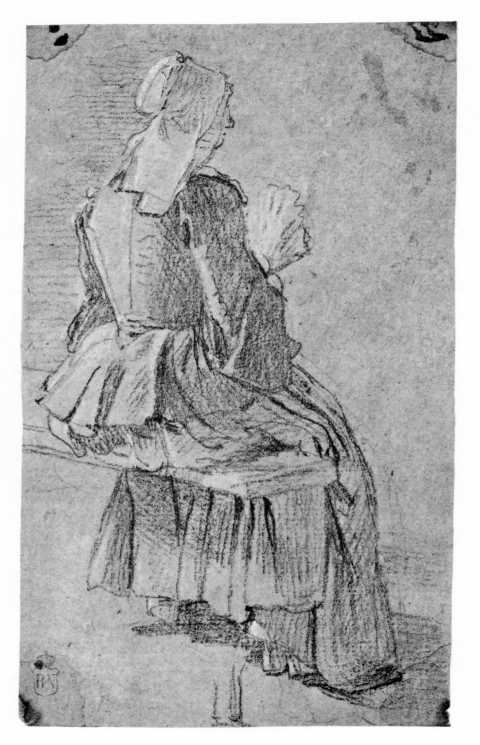

Plate 64
Francisco BAYEU
Seated Woman
pencil with highlights on
greenish-gray paper
8 15⁄16 x 7 1⁄8 inches
Madrid, Biblioteca Nacional

Plate 65
Francisco BAYEU
Seated Man
pencil with highlights on
greenish-gray paper
8 15⁄16 x 7 1⁄8 inches
Madrid, Biblioteca Nacional

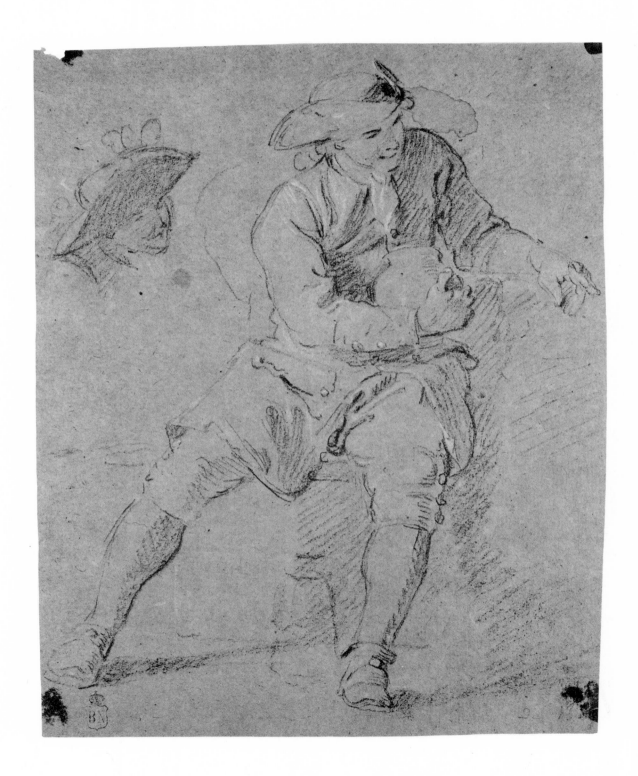

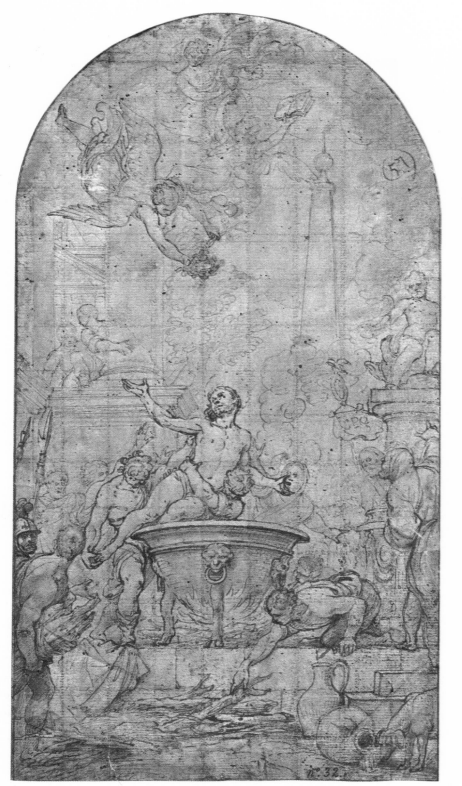

Plate 66
Claudio COELLO
The Martyrdom of
St. John the Evangelist
pen and wash in sepia ink
15¾ x 8⅜ inches
Madrid, Prado

Plate 67
MAELLA
The Family of Charles IV
Study for an unknown painting
quill pen and pencil
10⅞ x 7¾ inches
Madrid, Prado

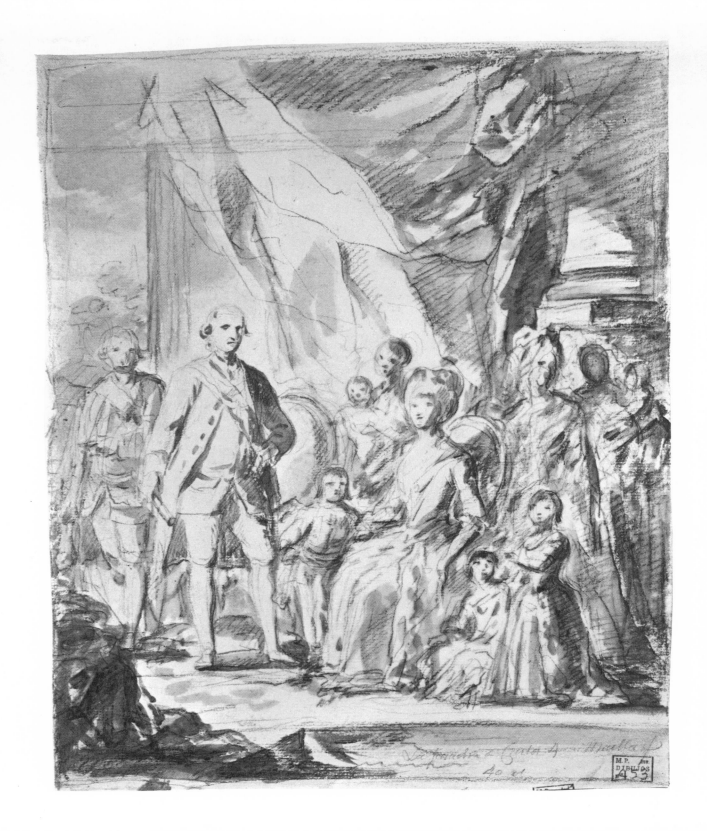

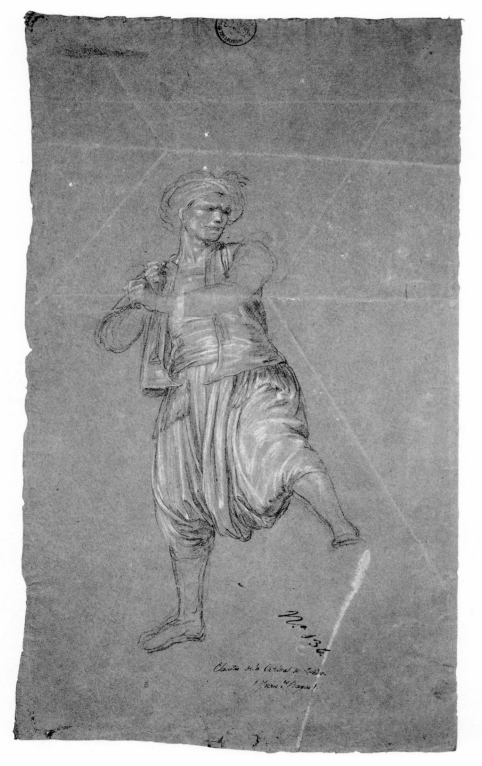

Plate 68
Francisco BAYEU
*Study of a turbaned figure for the
cloister fresco in the Cathedral of
Toledo*, after 1779
pencil with touches of white on
blue paper, 17½ x 11 inches
Madrid, Prado

Plate 69
Francisco BAYEU
Kneeling Courtier
red stone with touches of white on
gray paper, 17¹¹⁄₁₆ x 10¾ inches
Madrid, Prado

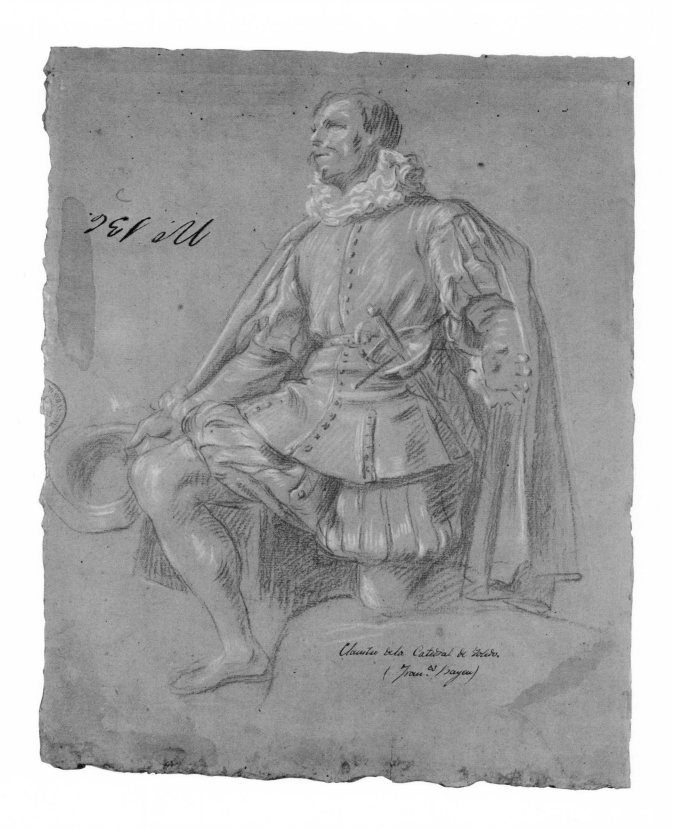

Claustro de la Catedral de Toledo.
(Franc.º Bayeu)

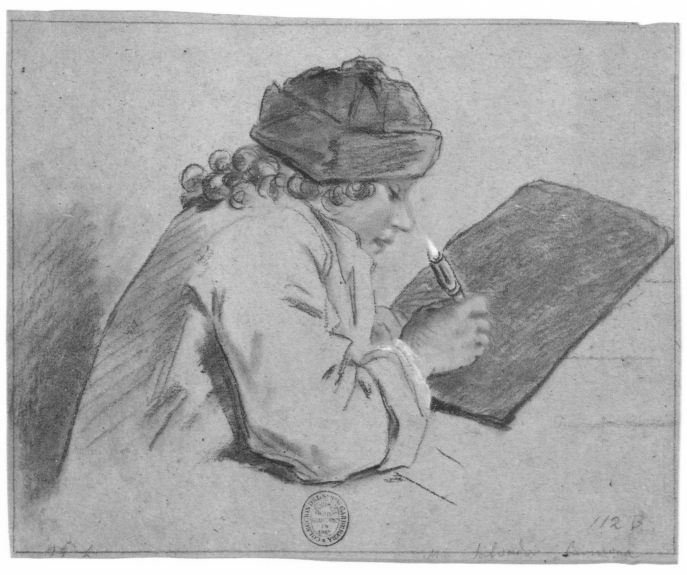

Plate 70
Manuel CARMONA • *Portrait of the Artist's Son* • pencil with red touches, 8⅛ x 9¾ inches • Madrid, Biblioteca Nacional

Plate 71
Francisco GOYA
She Leaves all to Providence
brush and India ink on white paper
10 x 7 inches
Bradford, Pennsylvania, Mr. T. Edward Hanley

Plate 72
Francisco BAYEU
Bowing Man
pencil with touches of white
7³⁄₁₆ x 5⅛ inches
Madrid, Biblioteca Nacional

Plate 73

Ramon BAYEU · *Déjeuner sur l'herbe* · pencil on slightly yellowed paper, 7½ x 11⅜ inches · Madrid, Biblioteca Nacional

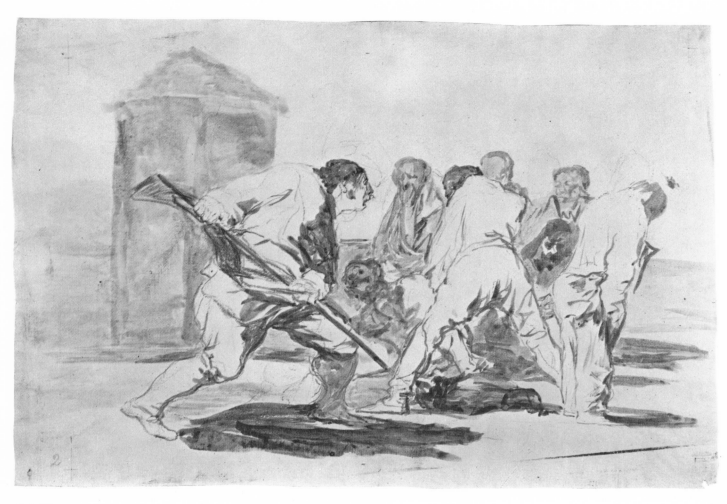

Plate 74
Francisco GOYA · *Foolish Fury* · sanguine and sepia, 9⅝ x 12¹³⁄₁₆ inches · Madrid, Prado

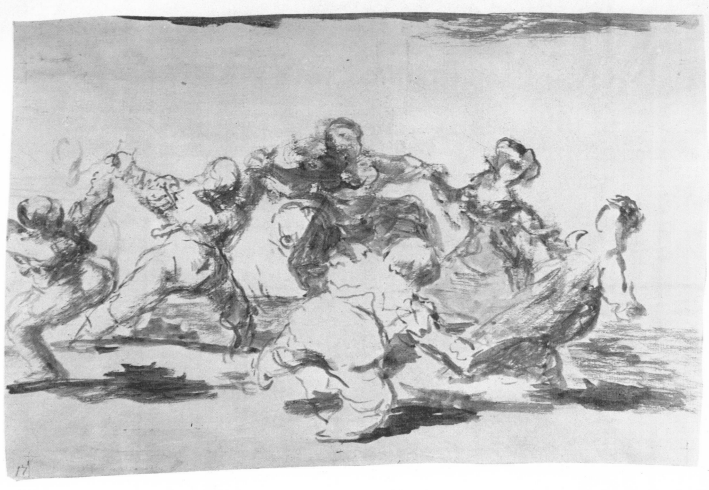

Plate 75
Francisco GOYA · *Dance of Majos and Majas* · sepia pen, wash, 9⅝ x 13⅞ inches · Madrid, Prado

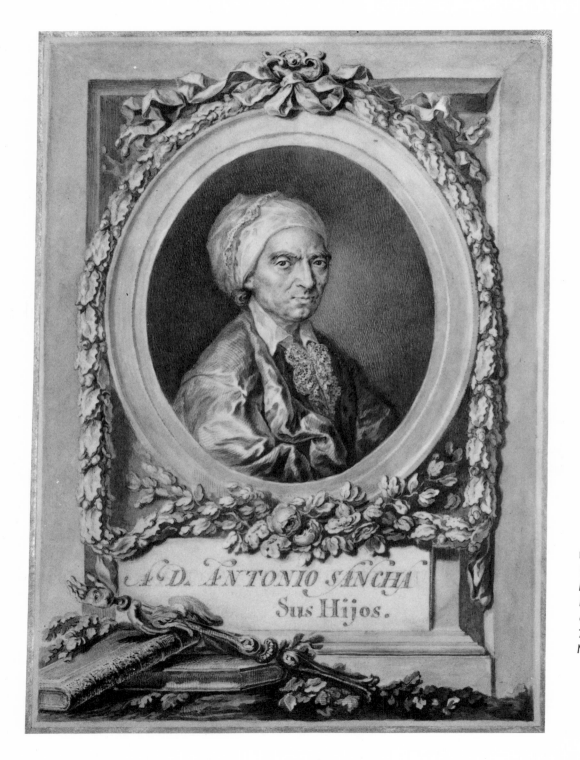

Plate 76
Luis PARET
Portrait of the Printer,
Don Antonio Sancha
quill pen with washes
7 $\frac{11}{16}$ x 5 $\frac{3}{8}$ inches
Madrid, Biblioteca Nacional

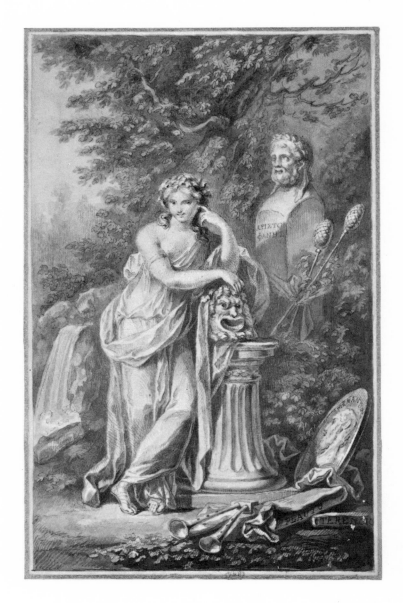

Plate 77
Luis PARET
Thalia, Muse of Comedy
Illustration for "Parnaso"
by Quevedo
quill pen and washes
5⅞ x 3³⁄₁₆ inches
Madrid, Biblioteca Nacional

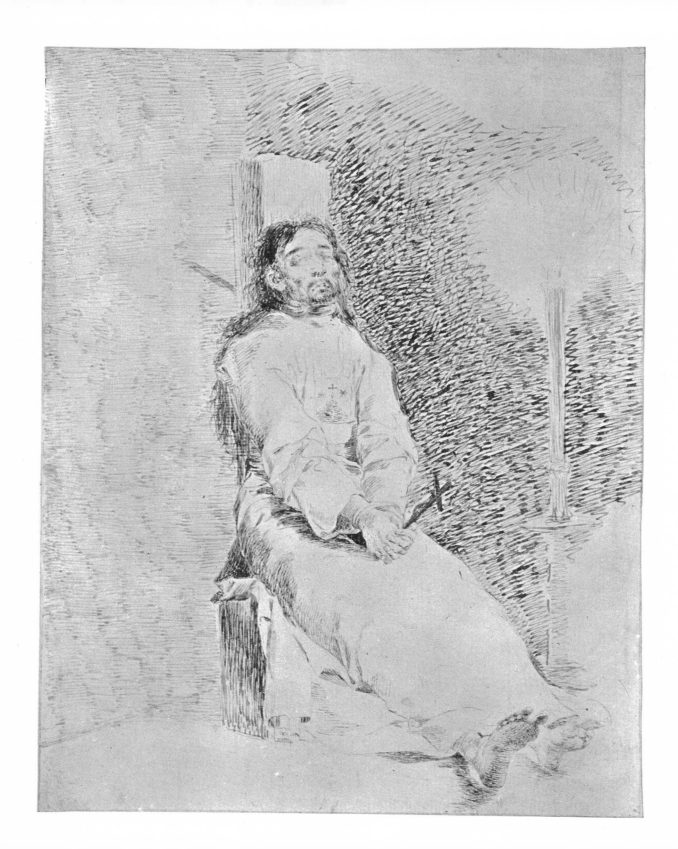

Plate 78
Francisco GOYA
The Garrote
sepia ink, 10⅜ x 7⅞ inches
London, The British Museum

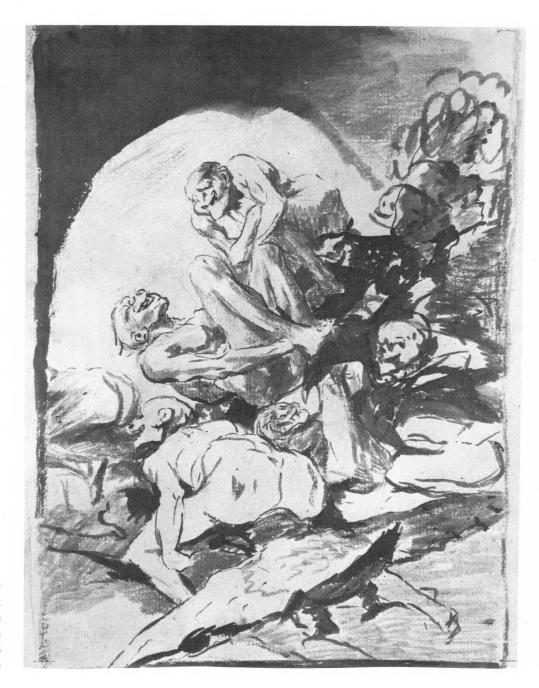

Plate 79
Francisco GOYA
Gathering of Witches
pen, ink wash
7½ x 5½ inches
Madrid, Prado

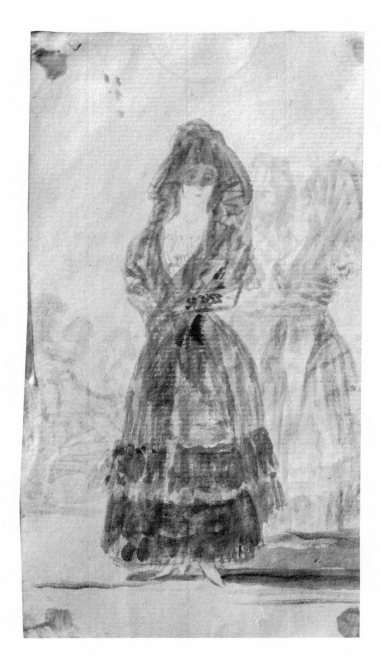

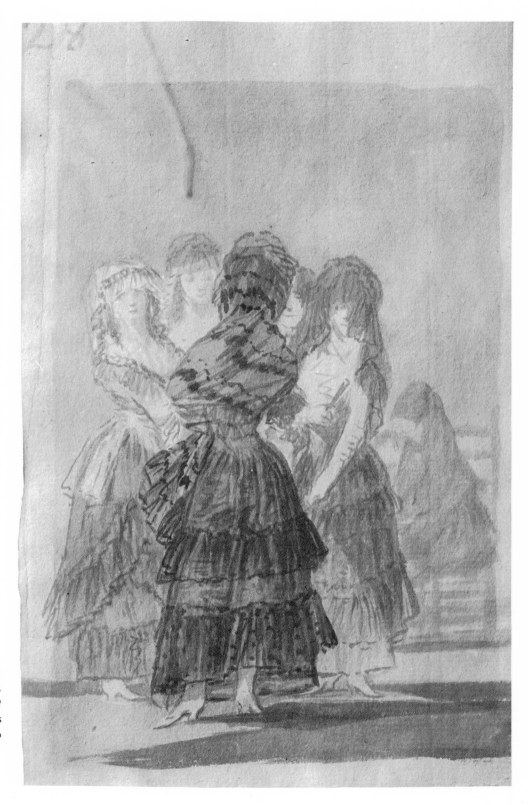

Plate 81
Francisco GOYA
The Visit
sepia ink, 8¼ x 5⁵⁄₁₆ inches
Madrid, Prado

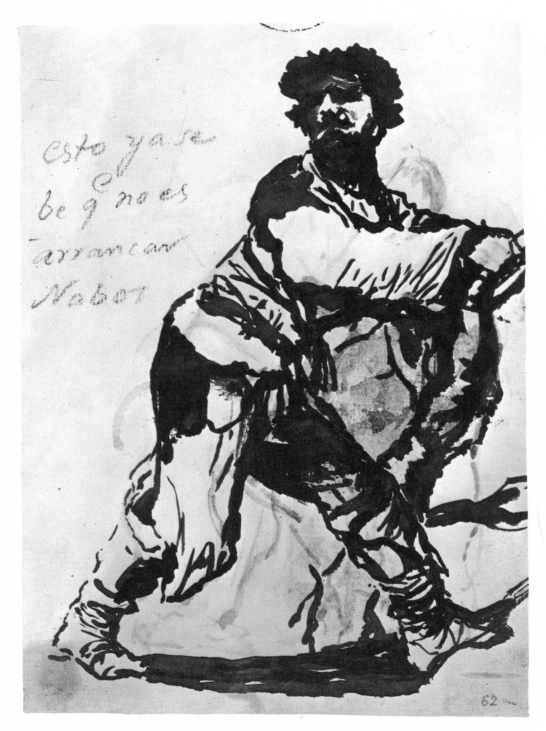

Plate 82
Francisco GOYA
*One can see this is not as easy
as pulling up turnips*
sepia ink, 6½ x 7½ inches
Madrid, Prado

114

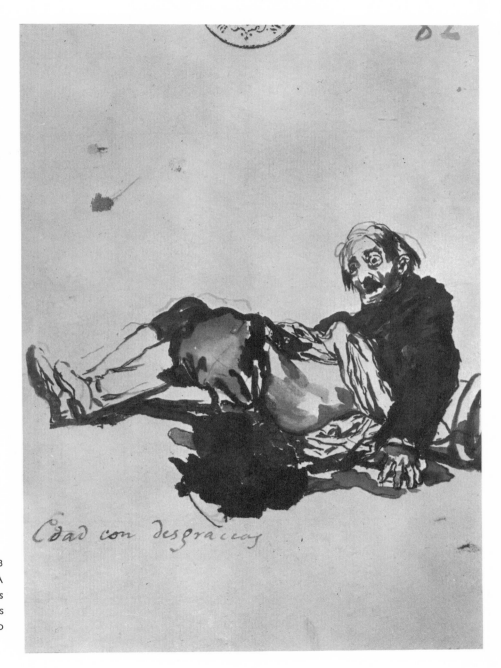

Plate 83
Francisco GOYA
Age with Misfortunes
sepia ink, 7⅞ x 5½ inches
Madrid, Prado

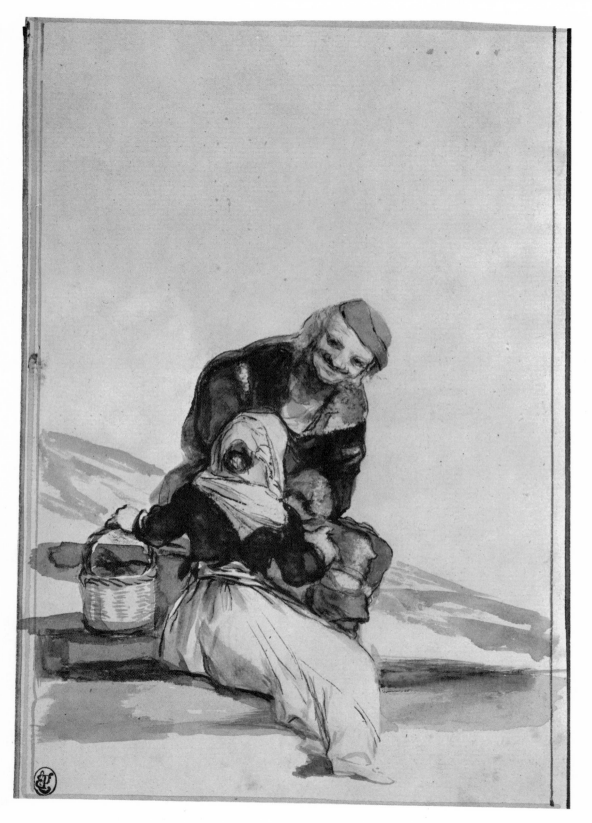

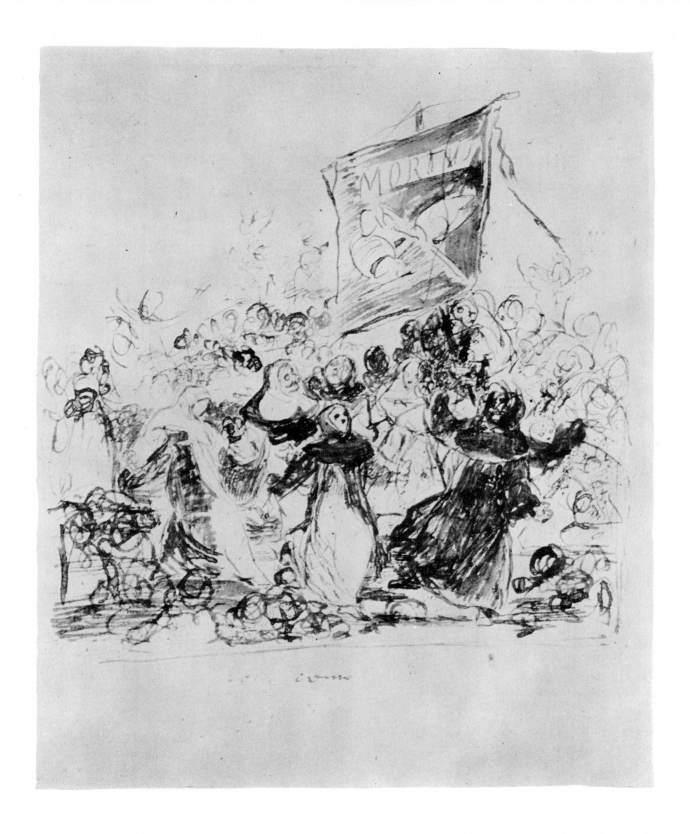

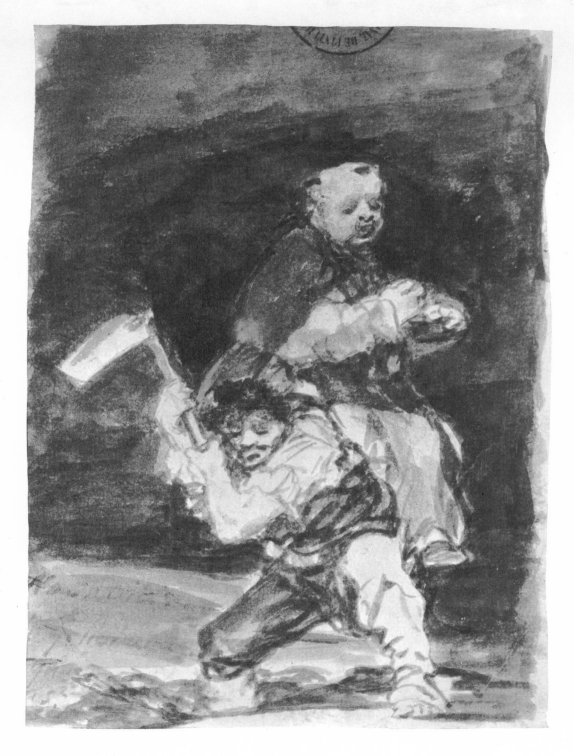

Plate 86
Francisco GOYA
Nosotros trabajamos
(We work…
rest of caption illegible)
sepia ink, 7½ x 5½ inches
Madrid, Prado

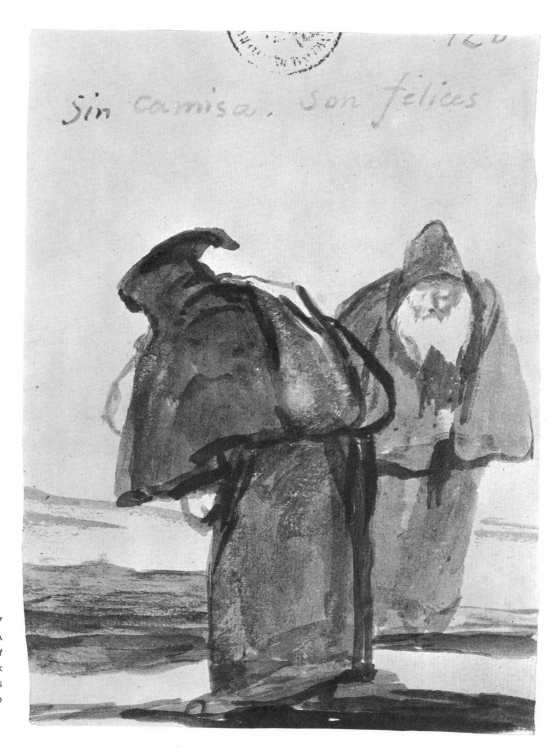

Plate 87
Francisco GOYA
They are Happy without a Shirt
India and sepia ink
7½ x 5½ inches
Madrid, Prado

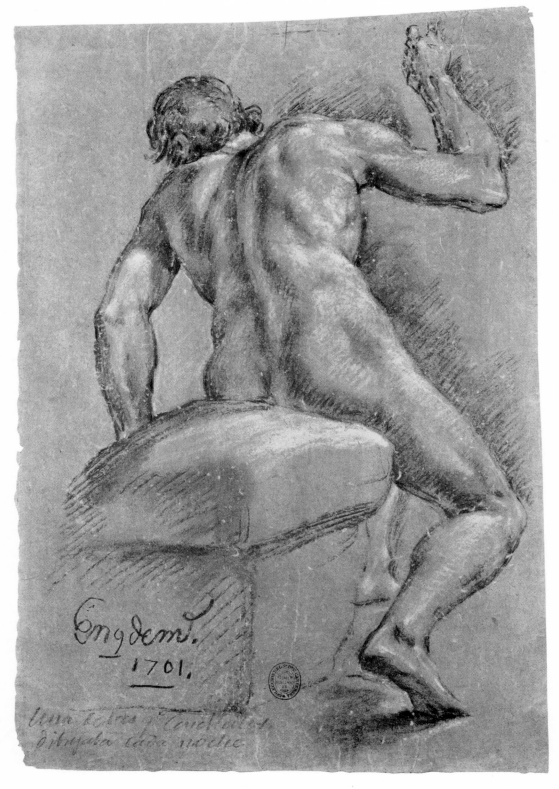

Plate 88
Juan CONCHILLOS
Nude Man, Seen from the Back
black chalk, heightened with
white, on blue-gray paper
16 15/16 x 11 7/16 inches
Madrid, Biblioteca Nacional

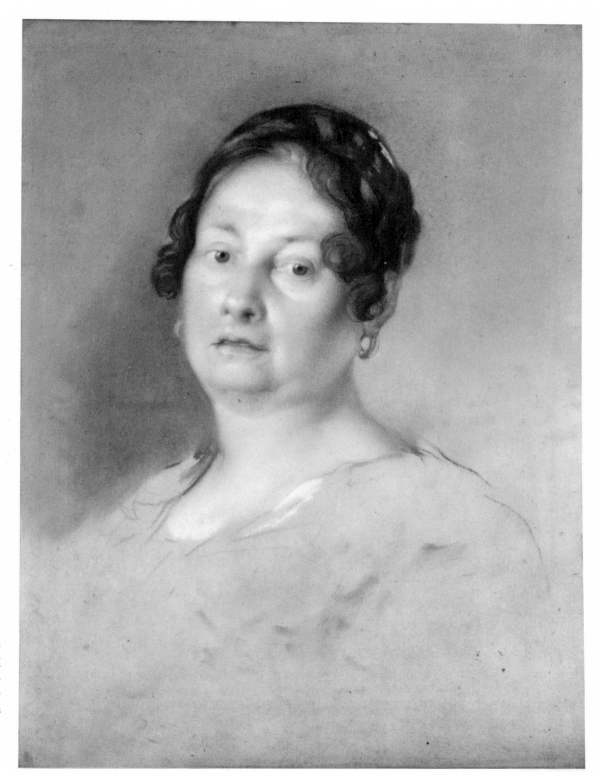

Plate 89
LOPEZ
*Portrait of Señora de
Camarón y Melía*
pastel, 22⅞₆ x 17¹¹⁄₁₆ inches
Madrid, Prado

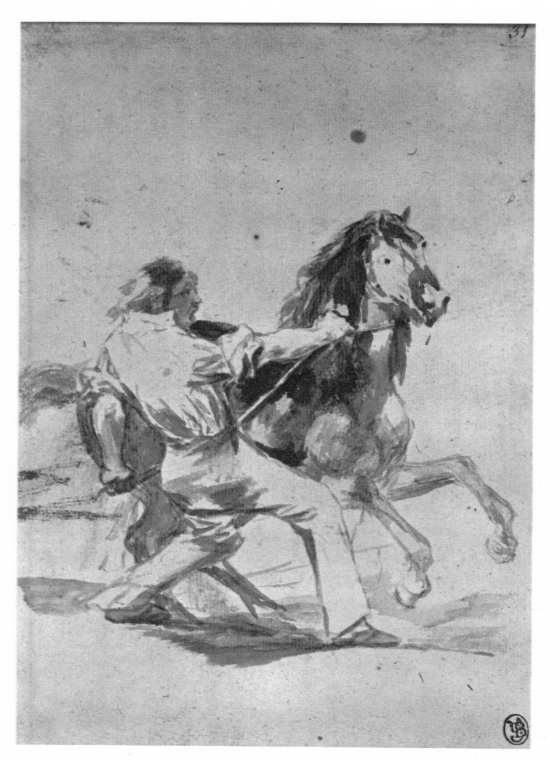

Plate 90
Francisco GOYA
Man Taming a Horse, c. 1819
sepia wash, 7¾ x 5¼ inches
Bradford, Pennsylvania
Mr. T. Edward Hanley

Plate 91
Federico MADRAZO
*Portrait of
Mariano José de Larra, "Fíagro"*
signed September 26, 1834
pencil, 9⅛ x 6⅞ inches
Madrid
Museo de Arte Moderno

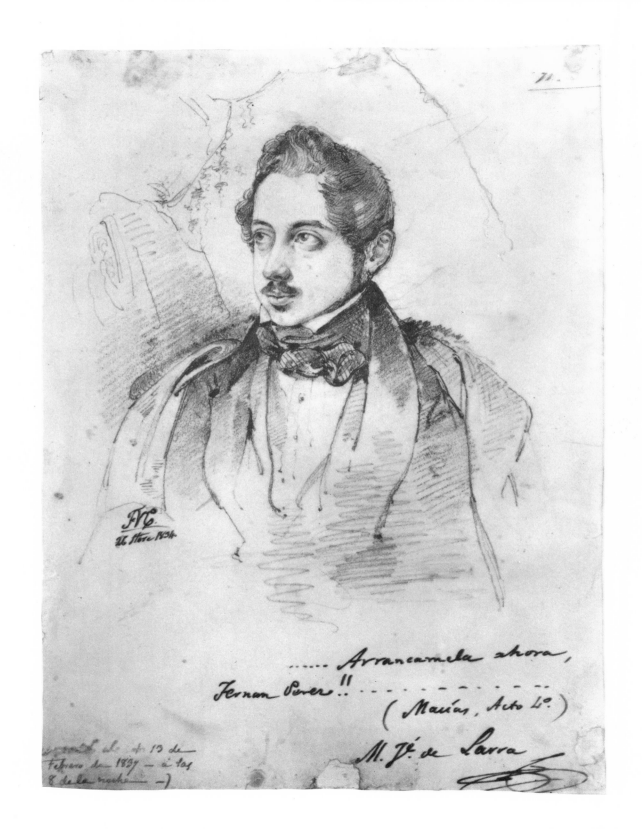

...... Arrancámela ahora,

Fernán Pérez!! .. - - - - - - - - --

(Macías, Acto 4º.)

M. J. de Larra

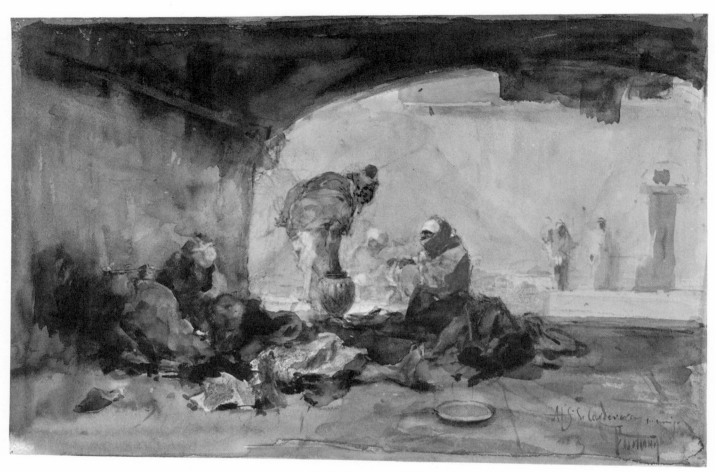

Plate 92
Mariano FORTUNY • *Untitled (A Moroccan Sketch)* • water color on paper, 10$\frac{15}{16}$ x 16$\frac{9}{16}$ inches
New York, The Hispanic Society of America

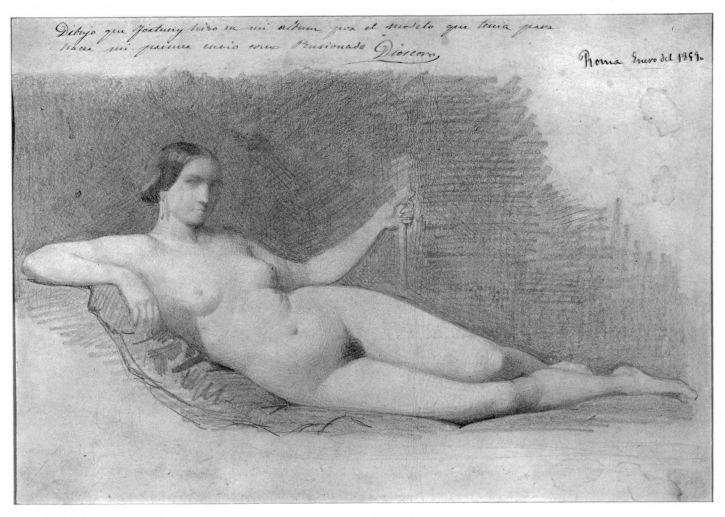

Plate 93
Mariano FORTUNY · *Reclining Nude*, Jan. 1859 · pencil on colored paper, 7 13/16 x 10 11/16 inches · Madrid
Real Academia de Bellas Artes de San Fernando

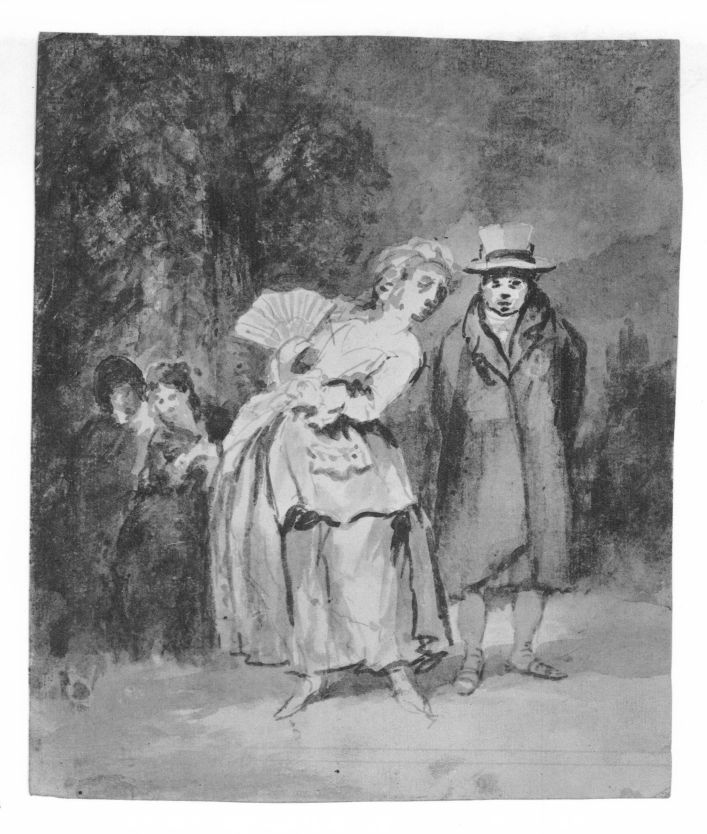

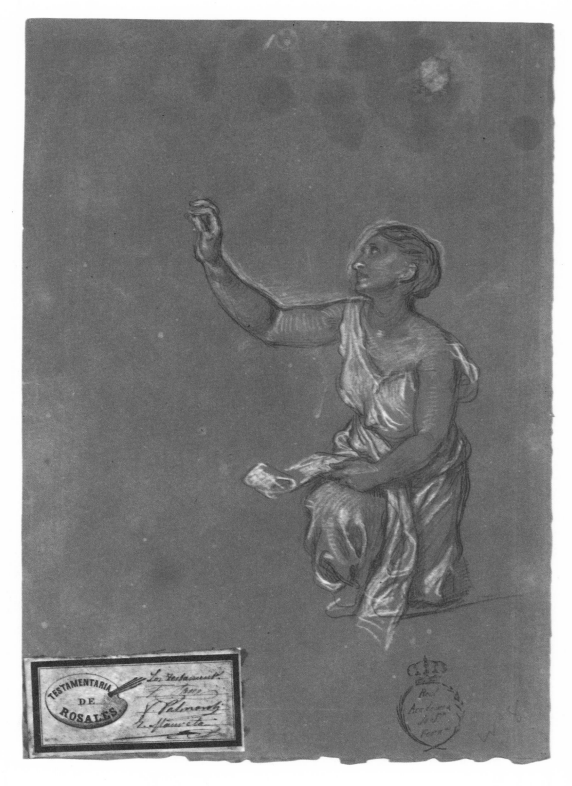

Plate 94
Eugenio LUCAS y Padilla
Couple Promenading
brush and black,
gray and brown washes
10¼ x 8¼ inches
New York
The Pierpont Morgan Library

Plate 95
ROSALES
Figure of a Woman
pencil with touches of white
10⅜ x 7⁷⁄₁₆ inches
Madrid, Real Academia
de Bellas Artes
de San Fernando

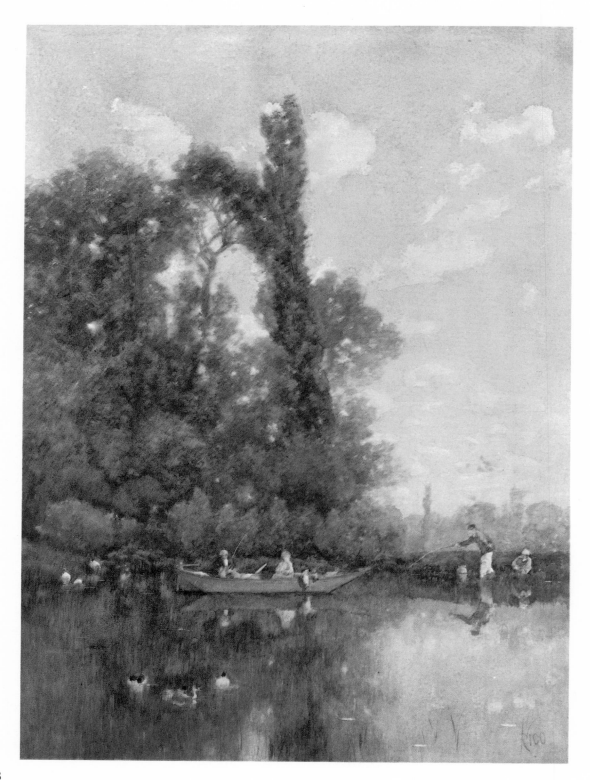

Plate 96
Martin RICO y Ortega
Landscape
water color on paper
14$\frac{15}{16}$ x 10$\frac{7}{16}$ inches
New York
The Hispanic Society
of America

Biographies

Francisco BAYEU

Francisco Bayeu y Subias (1734-1795) was an Aragonese painter who resided in Madrid since his youth. A disciple of Anton Raphael Mengs and a brother-in-law of Goya, whom he initially protected, he painted many oils and frescoes and was a prolific draughtsman.

Ramon BAYEU

Ramon Bayeu y Subias (1746-1793) was the brother of Francisco Bayeu y Subias and studied with him. Although an admirer of Ribera and Tiepolo, many of the motifs chosen by him are very French in character.

Alonso BERRUGUETE

Alonso Berruguete (1486-1560) was a painter and the most brilliant of the Castillian sculptors. He lived in Italy but his main works are in Valladolid and in Toledo. The mannerism of his paintings is in sharp contrast to the passion and sense of movement in his sculptures.

José CAMARON

José Camarón y Boronat (1730-1803) was a Valencian painter who alternated religious and allegorical compositions with genre studies.

Alonso CANO

Alonso Cano (1601-1667) was a painter, sculptor, and architect of Granada and the best and most prolific Spanish draughtsman of the 17th century. Anxious to achieve perfection, he studied more than he performed. He was a friend of Velázquez.

Vicente CARDUCHO

Vicencio Carducci was known in Spain as Vicente Carducho (1576-1638), a Florentine who, as a child, accompanied his brother Bartolomeo to El Escorial. He painted during the transitional period between Mannerism and Baroque styles and also wrote on painting. In the service of the King, he was a colleague of Velázquez but not his admirer.

Manuel CARMONA

Manuel Salvador Carmona (1734-1820) was an engraver who lived in Paris and in Rome, where he married the daughter of Anton Raphael Mengs. He was an excellent draughtsman and book illustrator, and did a number of admirable portraits.

Juan CARRENO

Juan Carreño de Miranda (1614-1685) was an Asturian painter who resided in Madrid almost his entire life. The most gifted of Velázquez' successors, he was a remarkable portraitist who also did religious and decorative painting in fresco.

Antonio del CASTILLO

Antonio del Castillo Saavedra (1616-1688) was a native of Cordova and, after Alonso Cano, the best and most prolific draughtsman in 17th-century Spain. He used to sign his works with the curved, interlaced letters A and C, which has sometimes been misinterpreted and confused with Alonso Cano whom he does not resemble in technique.

Pablo de CESPEDES

Pablo de Céspedes (b. 1538) was born in Cordova and was an important painter, sculptor, architect and writer.

José CHURRIGUERA

José Churriguera (1665-1725) was an architect and sculptor from Salamanca who personified—and gave his name—to the most exaggerated style of Baroque architecture in Spain. He had an inventive imagination, his execution was exquisite, and he distinguished himself in the design of large and lavish retables.

Claudio COELLO

Claudio Coello (1642-1693) was a Madrid painter and colleague of Carreño with whom he is comparable in many respects. His masterpiece is the retable of the sacristy of the monastery at El Escorial where he demonstrated himself to be a great portraitist and master of decorative painting.

Juan CONCHILLOS

Juan Conchillos (1641-1711) founded an academy of drawing in his native city of Valencia. He left a large number of excellent sketches of male nudes, on gray-blue paper in charcoal with white touches, signed with day, month and year, and, sometimes, even with the hour. Little is known of him as a painter.

EMETERIUS PRESBYTERUS

Emeterius Presbyterus signed, with the artist Monius, on July 28, 970, the manuscript of *Explanatio in Apocalypsis S. Johannis* by San Beato de Liévana, at the Tábara monastery. He was called a disciple of Magius "arcipictore" who died in 968.

FACUNDUS

Facundus decorated the manuscript, *Commentary on the Apocalypse* (1047), made for King Ferdinand I. It is now in the Biblioteca Nacional, Madrid, in a remarkably good state of preservation.

Mariano FORTUNY

Mariano José María Bernardo Fortuny (1838-1874) was a Catalan painter who resided in Italy a long time and died in Rome. An unsuccessful artist, in terms of recognition in his own time, he painted 18th-century scenes, Morocco leather, landscapes and was a watercolorist, draughtsman and engraver.

Francisco GOYA

Francisco Goya y Lucientes (1746-1828) was an Aragonese who lived most of his life in Madrid. He went to Italy as a young man and died in Bordeaux, France. With El Greco and Velázquez, he forms the famous triumvirate of Spanish art. He was an exceptional draughtsman and left an enormous number of drawings, many of them preparatory sketches for his five series of etchings. The Prado alone has 490 of his drawings.

El GRECO

Domenikos Theotocopoulus or Dominiko Theotocopuli, called El Greco (1540-1614), was a painter, born in Crete, who came to Spain and settled in Toledo in 1577 after having lived in Venice and Rome. He became thoroughly Spanish in his spirit and in his art, and his characteristic style cannot be confused with any other painter. One of the three great artists of Spain, along with Velázquez and Goya, his works have become newly appreciated in the 20th century.

Juan GUAS

Jean Houasse (?) or Juan Guas (fl. second half of the 15th century) was probably born in France. As early as 1459 he was employed as a sculptor and architect in Toledo. His chief work was the Church of San Juan de los Reyes of Toledo for which he also designed the main retable. Guas is considered the most outstanding artist of the late Gothic style in Spain.

HERRERA "El Mozo"

Francisco de Herrera "El Mozo" (The Younger) (1622-1685) of Seville was the son of the Spanish painter of the same name. He was the most typical representative of the pictorial Baroque style in Spain. An architect and engraver, he became vice president of the Academy of Painting of which Murillo was president. In 1675 he went to Madrid and became Court painter.

Jusepe LEONARDO

Jusepe or José Leonardo (ca. 1605-1656) was an Aragonese who painted in Madrid. Had he not suffered reverses, he might have been the heir of Velázquez. He painted two battlescenes for El Buen Retiro and several religious paintings.

LOPEZ

Vicente López y Portaña (1772-1850) was a Valencian painter who studied in both the Academy of San Carlos and San Fernando in Madrid. He was a draughtsman for many engravings and is best known for his portraits and large religious compositions.

Eugenio LUCAS y Padilla

Eugenio Lucas y Padilla (1824-1870) was born in Alcalá and died in Madrid. In his paintings of figures, landscapes and portraits, he imitated both Goya and Velázquez.

Federico MADRAZO

Federico Madrazo (1815-1894), born in Rome, was a painter's son. More notable as a portraitist than for his other compositions, he became Court painter to Isabel II and Alfonso XII. He was a brilliant draughtsman.

MAELLA

Mariano Salvador Maella (1739-1819) was born in Valencia and became the

Director of the Academy in Madrid. He was a prolific draughtsman and painter.

Teodosio MINGOT

Teodosio Mingot (d. 1590) was an Aragonese painter about whom very little is known. The drawing reproduced in this book shows, in old characters, "By the hand of Teodosio Mingot," a modest attribution which may be believed. The Italian influences on his style are evident.

MONIUS

Monius or Monii, a disciple of Magius, signed in 970, together with Emeterius Presbyterus, the manuscript *Explanatio in Apocalypsis S. Johannis* by San Beato de Liévana for the Tábara monastery.

Bartolomé MURILLO

Bartolomé Estéban Murillo (1617-1782) was a great religious painter of Seville. Modern critics admire the surprising technical advances in some of his works and the tenderness and color of his genre subjects, portraits and landscapes.

NAVARRETE "El Mudo"

Juan Fernández de Navarrete "El Mudo" (The Mute) (ca. 1526-1579) was born in Logroño and was a disciple of Titian. Philip II esteemed his work so much that he was entrusted with the altar paintings for El Escorial.

Francisco PACHECO

Francisco Pacheco (1564-1654) was a painter, teacher, author, classical scholar and amateur theologian who lived most of his life in Seville. His best-known pupils were his son-in-law Velázquez, Alonso Cano and possibly Zurbarán. He wrote *The Art of Painting, its Antiquity, its Greatness,* which was first

published in Seville in 1649 and is the most important 17th-century source of information about Spanish painters.

Luis PARET
Luis Paret y Alcázar (1746-1799), a native of Madrid, was a disciple of the Frenchman Charles de la Traverse. He is the most graceful and elegant of 18th-century Spanish artists and specialized in genre scenes and landscapes with small figures and was also a book illustrator.

Antonio de PEREDA
Antonio de Pereda y Salgado (ca. 1608-1678) was born in Valladolid but usually lived in Madrid. Although he collaborated with Carducho, Jusepe Leonardo, and Zurbarán in the battlescenes for El Buen Retiro, most of his work was of religious themes.

Francisco RIBALTA
Francisco Ribalta (d. 1628) was a Catalan who worked in Castile and Valencia, and traveled in Italy. From as early as 1582, one observes in his paintings a realistic sense and a concern with problems of light that place him in the vanguard of the Spanish painters influenced by the great Roman naturalist master, Caravaggio.

Jusepe de RIBERA
Jusepe or José de Ribera, called "Lo Spagnoletto," (1591-1652) was a Valencian who lived most of his life in Naples, which was then the capital of the viceroyalty of the Two Sicilies, belonging to Spain. He mastered the problem of light and shade in his paintings and progressed from the dark shadows of "tenebrism" to "luminism." Technically he surpassed most of his Italian contemporaries and is appreciated more by modern critics in recent years than three decades ago. He was also an engraver.

Martin R I C O y Ortega

Martin Rico y Ortega (1833-1908) was born in Madrid. He became a painter of landscapes and genre scenes and, when living in Rome, associated with Madrazo and with Fortuny.

R O S A L E S

Eduardo Rosales y Martínez (1836-1873), born in Madrid, was a pupil of Federico Madrazo. He painted innumerable portraits, historical and genre scenes.

V A L D E S Leal

Juan de Valdés Leal (1622-1690) was a painter of Seville whose place in Spanish art is parallel, in a way, to Claudio Coello in Madrid. He painted religious scenes almost exclusively, although there are a few portraits and allegories from his hand. He was more of a colorist than a draughtsman.

Diego V E L A Z Q U E Z

Diego Velázquez de Silva (1599-1660) was born in Seville and became the pupil and son-in-law of Francisco Pacheco. He is the greatest single figure in Spanish art. Philip IV made him Court painter in 1623 and became his friend as well as his patron. He went to Italy twice, from 1629 to 1631 and from 1648 to 1651. Naturally curious and of a reflective turn of mind, he acquired a fine library and owned many prints and drawings. Partly because of the demands on him as an important court functionary, and partly because he always sought perfection in his works, Velázquez was not very prolific. With these studious and perfectionist traits, it is incredible that his known drawings are so scarce.

Bibliography

GENERAL

Ashmolean Catalogue: K. T. Parker, *Catalogue of the Collection of Drawings in the Ashmolean Museum,* Vol. I. "Netherlandish, German, French, and Spanish Schools," 1938, Oxford, 1938-56.

Barcia, A. M. de, *Catálogo de los Dibujos Originales de la Biblioteca Nacional,* Madrid, 1906.

Boix, F., *Expoción de Dibujos, 1750 a 1860,* Sociedad española de amigos del arte, Madrid, 1922 (1923).

Gómez Sicre, J., *Spanish drawings XV-XIX centuries,* New York, 1949.

Gradmann, E., *Spanische Meisterzeichnungen,* Frankfurt, 1939.

Mayer, A. L., *Handzeichnungen Spanischer Meister, 150 Skizzen und Entwürfe von Kunstlern des 16. bis 19. Jahrhunderts.* (New York Hispanic Society), Leipzig, 1915.

Rouchès, G., *Maîtres Espagnols du XVIIe siècle,* Paris, 1939.

Sánchez Cantón, F. J., *Dibujos Españoles, siglos X-XVII,* 5 Vols., Madrid, 1930.

Trapier, Elizabeth, "Notes on Spanish Drawings". *Notes Hispanic,* pp. 1-62. New York, 1941.

CANO

Wethey, A. E., *Alonso Cano: painter, sculptor, architect,* Princeton, 1955.

GOYA

d'Achiardi, P., *Les dessins de D. Francisco Goya y Lucientes au Musée du Prado à Madrid,* 3 Vols., Rome, 1908.

EL GRECO

Wethey, A. E., *El Greco and his school,* Princeton, 1962.

VELAZQUEZ

Lafuente, E., *The paintings and drawings of Velazquez,* London, 1943.

Mayer, A. L., *Velazquez, a catalogue raisonée of the pictures and drawings,* London, 1936.